EARLY MEDIEVAL ART

EARLY MEDIEVAL ART

with illustrations from the British Museum

and British Library collections

Revised Edition

ERNST KITZINGER

INDIANA UNIVERSITY PRESS

BLOOMINGTON and INDIANAPOLIS

Second Midland Book Edition 1983

Reprinted 1987, 1990

Copyright © 1940, 1983 by
the Trustees of the British Museum

*Library of Congress Cataloging
in Publication Data*

Kitzinger, Ernst, 1912–
 Early medieval art, with illustrations from the
British Museum and British Library collections.
 Previously published as: Early medieval art in the
British Museum.
 "Second Midland Book edition" – T. p. verso.
 1. Art, Medieval. 2. British Museum.
 I. British Museum. II. Title.
N5970.K55 1983 709'.02 83-47900
ISBN 0–253–11884–0
ISBN 0–253–20315–5 (pbk.)

Manufactured in Hong Kong

CONTENTS

PREFACE TO THE THIRD EDITION

The 'German refugee scholar' who was introduced in the preface to the first edition of this book is of course one of those gifted art historians from the continent of Europe who have gone on to distinguished careers in the universities of the English-speaking world. His *Early Medieval Art* is a classic, with a very special place in the affections of generations of students of art history and the Middle Ages. It has taught them to understand – and, more important, to *see* – the stages in the evolution of art from the naturalism of the Classical age to the religious fervour of the Medieval era.

It was an honour for me, as one of those students, to be asked to revise the book for its third edition: Professor Kitzinger travels extensively between Britain and the United States and did not have the time to avail himself of the opportunity. He has nevertheless been characteristically kind and generous with his help, and my gratitude is all the deeper for the knowledge that, having recently poured so much mature thought into his *Byzantine Art in the Making* (Harvard and London, 1977), he was understandably hesitant about returning to a work he had written in his twenties. The broad canvas and timeless qualities of *Early Medieval Art*, however, ensure its lasting popularity; far from merely recording the state of Early Medieval art historical knowledge in the 1930s, it has perpetual value as an inspired introduction to the whole world of art history, regardless of period.

In conformity with the modern practice in Medieval circles, I have used 'Byzantium' for the Byzantine world rather than for its capital, Constantinople. 'Archaic' has been retained to describe a stylised art reminiscent of Greek sculpture before the naturalism of the Classical period, and 'abstraction' also remains, meaning 'a diminution of naturalism'. Since there are no BC dates in *Early Medieval Art*, the 'AD' has been omitted as superfluous. Some dates have been altered, after reference to the author, and, in accordance with his wishes, the sharp distinction made in the earlier editions between the eastern Mediterranean littoral and the Asiatic hinterland has been blurred.

To colleagues in the British Museum, particularly Terence Mitchell and Morris Bierbrier of the departments of Western Asiatic and Egyptian antiquities respectively, I extend my sincere thanks for help and support. I am especially grateful to Janet Backhouse, of the Department of Manuscripts of the British

Library, on whom – because of the now separate identities of the Museum and Library – so much of the work has fallen. In view of Professor Kitzinger's long association with Dumbarton Oaks, it is fitting that the earlier part of my revision was completed there, and I thank the Director, Fellows and staff for their warm hospitality.

DAVID BUCKTON

Dumbarton Oaks
Washington, D.C.
October – November 1982

The British Museum
London WC1
December 1982 – February 1983

EARLY MEDIEVAL ART

FIGURE I

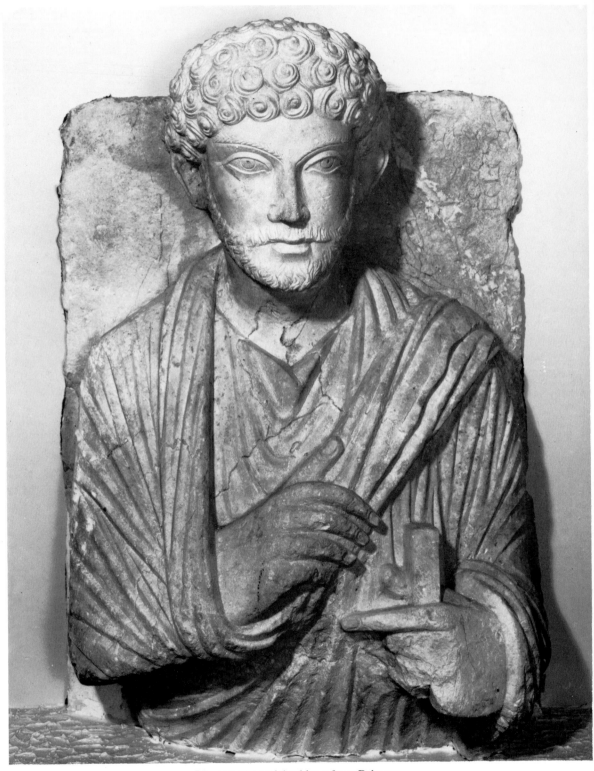

Limestone sepulchral bust from Palmyra.
Second century. Height 63·5 cm.

I

THE LATE ANTIQUE AND EARLY CHRISTIAN PERIOD

The student of Early Medieval art is faced with the difficult task of deciding at what date the Middle Ages began. Some historians have settled for 313, the year of the Edict of Milan, through which Christianity became recognised as a state religion; others hold that the abdication of the last Roman emperor in 476 marks the turning point between the Classical and Medieval periods, while yet another view favours the foundation of the first Germanic empire under Charlemagne in the year 800.

The last date is the one most frequently adopted by art historians: it is not customary to talk of Medieval art before the ascendancy of a Christian civilisation in northern Europe. The preceding centuries, known in art history as 'Late Antique' and 'Early Christian', were long a kind of no-man's-land, rarely entered by the Classical archaeologist and even more seriously neglected by the medievalist. Art was thought to have come to an end under the later Roman emperors, and the five hundred years which elapsed between the age of Constantine (306–337) and that of Charlemagne (768–814) were regarded as devoid of interest from the art historical point of view. What attention they did attract was warranted by religious rather than aesthetic considerations, this being the period when the first churches were built and representations of Christ and of many Christian subjects took shape.

During the last few decades, however, research has revealed more and more clearly the great importance of the art of these intermediate centuries. Far from having been merely decadent and dull, it is now known to have played a vital role in the evolution of Medieval style. Its significance is twofold: first, it ensured the continuance of the Classical tradition, which was in grave danger of dying out with the disappearance of pagan religion and pagan civilisation, and, secondly, it provided the starting point for that process of transformation by which the Classical style of the Greeks and Romans changed into the abstract and transcendental style of the Middle Ages.

11

It may be surprising to hear that the Classical tradition continued into Medieval art, but we must understand that the very existence of representational art in the Middle Ages is an illustration of Classical survival. At first Christianity was averse to any kind of image, rejecting it not only as a possible source of idolatry but also as a symbol of worldly splendour and luxury; it was as a concession to paganism that art was admitted into the Church, and consequently many details of Antique iconography and style found their way into Christian art and survived into the Middle Ages. Neither do we always realise that what appears fundamentally to distinguish Medieval from Classical art – its naïve, primitive and archaic character – was the result not so much of the influence of the barbarians of northern Europe as of a gradual internal transformation detectable in Late Classical art even before pagan Roman art had come to an end. The Early Christian centuries thus occupied a key position between the Classical and Medieval periods, and, however brief, a survey of the development during these centuries is essential to an understanding of Early Medieval art.

It was during the third and fourth centuries that the Christians began to adapt Classical art to their purposes. We have little evidence of what may properly be called artistic activity among Christian communities during the first two centuries of their existence, but the more followers they attracted in the large cities of the Graeco-Roman world the more difficult it became to maintain the austerity of the primitive Church. If the average pagan convert could not be expected to give up the pleasant and beautiful things with which he surrounded himself in his everyday life, still less could he be expected to exclude the arts from his religious observance: accustomed to an array of marble statuary representing the gods he worshipped, he would be difficult to attract to a religion which had no more tangible object of veneration to offer him than the written word.

Early Christian art betrays this origin in its entire character. The earliest Christian works of art were produced in a completely pagan environment; in the third and fourth centuries there were probably painters and sculptors who worked for both a Christian and a pagan clientele, and it is small wonder that Christian art borrowed from contemporary pagan art its style and sometimes even its subject-matter. There are many instances of Classical figures being taken over unchanged by Christian artists. We find Cupids, personifications of the seasons and other pagan allegorical subjects in the wall-decorations of Roman catacombs belonging to this period; Tritons and Nereids were frequently represented on Christian sarcophagi.

FIGURE 2

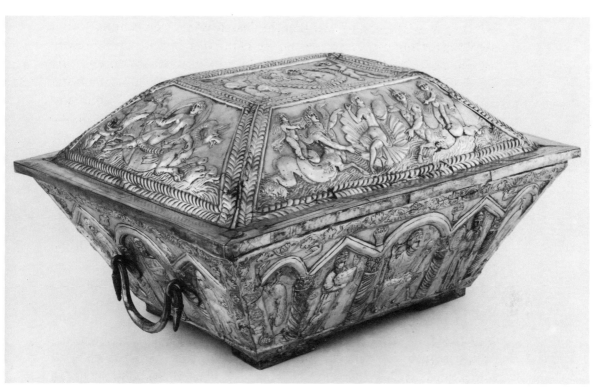

The Projecta Casket, from Rome.
Second half of fourth century. Length 56cm.

All these figures were regarded as compatible with the new religion; they were general symbols of the next world and eternal happiness – matters of no less importance to Christians than to the heathen. A famous instance of pagan figures being taken over unchanged by Christians is the casket of Projecta (fig. 2), a silver casket decorated partly with idyllic pictures of Venus, Tritons, Nereids and Cupids and partly with scenes of ceremonies, while in the accompanying inscription the bride and bridegroom are exhorted to lead a Christian life. In the East, pagan figures were even more persistently employed than in Rome: Egypt, for example, having been thoroughly imbued with Hellenistic taste at the time of the Ptolemys, clung tenaciously to pagan art, and far into the Christian period garments and tapestries were being decorated with Classical figures.

Such cases of actual copying, however, although the most obvious examples of pagan survival, are not perhaps those which had the greatest bearing on the subsequent development of Christian art. As early as the third century attempts were made to give traditional figures a new and

specifically Christian meaning. We find pictures of Christ modelled on figures of Apollo, Helios, or some other youthful god or hero; no more suitable way could be found of expressing his divine mission than by giving him features universally associated with the gods. Even more frequently he was represented as a shepherd with his flock; while this theme was of course inspired by Gospel texts, Classical models were followed in rendering it. During the fourth century these youthful and idyllic representations of Christ began to be replaced by a more austere and majestic bearded type, but the inspiration again came from pagan art, the models being older Olympian gods, such as Zeus or Asklepios, or portraits of great philosophers, who symbolised supreme wisdom. Angels were easily derived from the Victories so frequent in Greek and Roman art, and the insignia of imperial power and military triumph became symbols of the victorious Church.

Characteristic examples of pagan iconography adapted to Christian ideas are provided by the gilded glasses found in great numbers in the Roman catacombs. For instance, the old Roman theme of a married couple united by Juno or a Cupid is either taken over unaltered or christianised by the simple but striking device of replacing the pagan deity by a figure of Christ (pl. 1). The writers of Gospel manuscripts conformed to the pagan custom of inserting at the beginning of the book a portrait of the author, in this case the evangelist, who was represented exactly as the Classical writers and philosophers had been; this was the origin of the evangelist portraits which played such a conspicuous part in Medieval book-illumination (fig. 17, pls 6, 9, 10). Nor was the process of adaptation confined to figural art: the Early Christian church had the form of the basilica of the Roman market-place, adapted to the requirements of the divine service.

These few examples show that Early Christian art was developed from pagan prototypes. It may even be assumed that the Christians, having begun to use art for their own purposes, made a point of adapting well-known Classical subjects so as to render the change in inner meaning all the more apparent. There were, however, many themes for which no models were available, notably New Testament stories; these had to be conceived afresh, and it is in these free inventions that the full force of the Classical tradition is apparent. There was certainly no prototype in pagan art for the Raising of Lazarus, but the artist naturally set the scene in front of a Classical tomb; the Entry into Jerusalem was modelled on an emperor's triumphal arrival at the gates of one of his cities. Such instances can easily be multiplied.

In company with Classical iconography, Classical style naturally penetrated Christian art. There is no stylistic difference between Christian painting and sculpture of the third and fourth centuries and contemporary pagan work. Catacomb paintings were executed in the manner familiar from the wall-decorations of Roman houses; the style in both cases is a debased version of the impressionistic manner evolved in the early days of the Roman Empire and seen to best advantage in the frescoes of Pompeii. The paintings of the Early Christian period were all executed in this versatile technique, capable of sketching with light brush-strokes a figure in lively action with a recognisable 'glance' in the eyes, surrounded by a landscape full of light and air. When the earliest manuscript illuminations were painted, this style was still alive, as is shown in the famous illustrations from the Cotton Genesis (fig. 7, pl. 3). There is nothing peculiarly Christian about these miniatures, which have their closest parallels in roughly contemporary illustrations of Virgil and Homer.

Neither pagan nor Christian works of art of this period lived up to the highest standards of Classical art, however. The Graeco-Roman style had completely degenerated by the time it was taken over by the Christians; even the outstanding works of Early Christian times like Projecta's casket cannot really be compared with the highest achievements of Roman art, to say nothing of the masterpieces of the Hellenistic period. In the best examples the figures recall earlier work, but usually a certain stiffness and awkwardness in the poses, a lack of proportion in the bodies and an absence of expression in the faces are all too evident. The artists imitated the traditional forms without entering into the spirit; the beauty of the best Classical art had disappeared altogether.

These works can be described in other than purely negative terms, though, if they are judged by the standards not of the Classical age which lay behind them, but of the Medieval period which they foreshadowed. The very features which from the Classical point of view appear as shortcomings acquire a new and positive value when seen in the light of the development which was to follow. For even the earliest Christian works are not merely instances of the survival of Classical features: they also illustrate the other aspect of our transition period which makes it important from the point of view of Medieval art – the transformation of the Classical into a transcendental, abstract style. To trace the origins of these abstract tendencies we must again go back beyond the beginnings of Christian art, since they appeared in Roman art as early as the second century and their foundations lie in an even remoter past.

While the Greeks achieved the ideal representation of the human body and the Romans perfected individual portraiture and greatly advanced the representation of landscape and three-dimensional space, there were at the same time people with different tastes and different traditions who did not share the Classical artist's concern with the naturalistic representation of the outside world. In the East, in Mesopotamia and Persia, the ancient heritage of a rigid and hieratic official art had never entirely died out. In the north-east, beyond the shores of the Black Sea, were the people of the Steppes, the most prominent among them the Scythians, who had no monumental art at all but only portable objects decorated with fantastic designs. This was also true of the barbarian peoples in the north and north-west, notably the Celts with their richly decorated bronze objects.

These self-contained cultures, with artistic ideals differing widely from the Classical, had little direct influence on the development of style in the Late Antique period; what is more important from our point of view was the existence of border regions between the Classical world and the eastern and barbarian lands. Classical art was as widespread as the empires with which it was associated. In Hellenistic times it was carried all over the Mediterranean by Alexander the Great; countries like Egypt were thoroughly hellenised at that time, and Classical influence was felt as far away as India. The same thing happened in Roman times, when the imperial legions carried Roman civilisation, and with it Classical art, to the Rhine, the Danube, the Thames, and all over North Africa and the Near East. Wherever it appeared, Graeco-Roman art was accepted as the standard, if only because it introduced to peoples previously unfamiliar with it the means of depicting lifelike human figures in stone, metal or paint. But Classical models followed by artists with quite different traditions naturally took on a local colour: the features of a figure were superficially the same as in Rome or Greece, but we often feel that the free pose, the lifelike and individualised expression of the face, the natural and easy relationship between figures – in short, all the essential qualities which the Greeks had discovered – have not been quite faithfully reproduced.

In many of these border regions we therefore find an art which is Classical in origin and general concept but not in spirit. Typical examples of such pseudo-Classical art are provided by lands in the Near East which had a strong artistic tradition of their own but sooner or later fell under Greek or Roman domination, among them North Africa, the Nile valley, Syria, Parthian and Sassanian Mesopotamia and Persia, inland Asia Minor and the island of Cyprus.

The style of this 'sub-Antique' art naturally varied with local traditions. In the mummy-case from Hawara (pl. 2), for instance, we see a particularly striking mixture of Classical and non-Classical features. The mummy-case itself is entirely in the Egyptian tradition, but the face painted on it is at first sight purely Roman; this mixture is usual in Egyptian mummies from around the time of the Roman occupation. In our example, which dates from the second century, we find a particularly naturalistic and individualised portrait with all its details modelled in the subtle pictorial technique of which Hellenistic and Roman artists were masters. Even in the face, however, there is an anti-Classical element, although it is psychological rather than stylistic: the fixed gaze seems to look beyond the spectator into infinity, and the whole life of the portrait is concentrated in the eyes, completely upsetting that harmony of the different parts of the face essential to truly Classical portraiture. It was in this emphasis of a spiritual element unconnected with the characterisation of an individual personality that the Egyptian portraitist differed from his Roman contemporary. Two hundred years later, artists in Rome were also producing 'portraits' which showed the artist and subject to have been conscious of an impersonal transcendental power more important than the physical features of the individual model.

A second-century bust from Palmyra (fig. 1) shows 'sub-Antique' art diverging from Classical standards in a different way. The artist clearly followed the model of official Roman art: the draping of the toga and the technique of the beard, for instance, are in the well-known manner of Roman portraits. But the details are interpreted in a purely ornamental manner: the curls of the hair are treated as conventional spirals and look as though they were made of some crisp pastry-like material, the eyebrows are almost like a palmette ornament, and the sharp and elegantly curved lines of the eyelids remind one of ornamental metalwork. The bust betrays that conventional approach to the human form which the Greeks, with their supreme mastery in portraying life and movement, had overcome but which began to reassert itself in the eastern part of Syria as early as the second century.

It is more difficult to recognise the ultimately Classical roots of works like a tombstone from the neighbourhood of Carthage (fig. 3), representing the provincial art of the North African coast. Were it not for the two figures in the upper corners, derived from well-known representations of Castor and Pollux leading their horses, this relief would perhaps be regarded as an entirely exotic work. The carving is flat, the figures all face the spectator

17

FIGURE 3

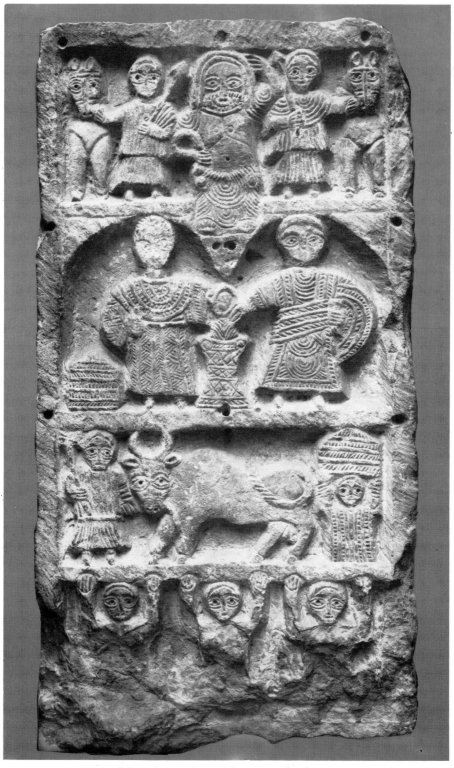

Limestone tombstone from near Carthage.
Probably second century. Height 78·5 cm.

FIGURE 4

Jewish limestone ossuary, from Jerusalem.
Probably first century. Length 83 cm.

squarely, their proportions are clumsy and their features grotesquely simplified; the folds of the garments have become completely stylised, with ornamental forms. Particularly important from the point of view of later development is the schematic order in the composition, the division of the panel into horizontal zones with a vertical axis dividing it in half. In its coarse and primitive way, the relief anticipates that complete negation of the principles of Classical art which the Early Middle Ages were gradually to bring about. At first sight this slab might appear to be a precocious product of the Dark Ages, but it is actually an extreme example of provincial Roman art, the work of a North African sculptor depicting the deities and symbols of a local cult.

Another regional style which flourished in the Mediterranean area side by side with the official Graeco-Roman art is exemplified by a Jewish stone cist or ossuary from Jerusalem (fig. 4), dating from about the first century. It is covered with patterns partly derived from Hellenistic

acanthus ornament and partly of eastern origin; in his treatment of the motif the artist has revealed an anti-Classical taste characteristic of many of the border regions of the Classical world. The ornament was executed by means of sharp v-shaped cuts, so that fully lit parts alternate with deep shadows. The space is thus completely filled with a pattern in black and white, the background of which is no less important than the motifs themselves; the intrinsic decorative value of the individual motif has been subordinated to this tonal effect. If we think for a moment of typical Greek or Roman ornament – for example, a foliate scroll on a plain ground – depending for its effect entirely on the beauty of its own design, we realise how different the principle is here. We shall see how important this anti-Classical ornament, which aimed at effects unrelated to the actual shape of the motif, was to become in later developments. Common to all these different examples of 'sub-Antique' art was the attempt to impose some abstract principle on the natural forms of Graeco-Roman art. In various ways, differing from place to place, the border regions of the Roman world cultivated deliberate stylisation in opposition to the naturalism of Classical art.

These 'sub-Antique' traditions would probably not have been so important had they been confined to the outer regions of the Classical world. The decisive factor was the increasingly strong influence exerted by provincial styles on the art of the great cities, beginning as early as the second century but becoming much more marked during the third and fourth. This was a development pointing to sweeping changes in the artistic ideals of those centres; in fact it has often been said that internal changes taking place in Rome and the other great cities at the time were far more important than any influence from outside, and that the evolution of Late Antique art was largely the result of a complete transformation within the Roman Empire. It is, however, impossible to disregard the strong ties between Late Antique style and the 'sub-Antique' art of the previous centuries which undoubtedly influenced its development. On the other hand, it would be hard to maintain that provincial styles were imposed upon the metropolitan cities against their will; the change was certainly not caused by provincial artists forcing their way into the big cities. On the contrary, the abstract style was adopted readily, and, since in the course of the third and fourth centuries it began to appear on the most important imperial monuments, it was clearly no longer regarded as provincial, inferior or connected only with the lower strata of the population but was spontaneously recognised as the official art of Rome.

This points to profound changes in Roman life and taste, involving the abandonment of everything achieved by Classical art since the period of archaic Greek sculpture. It marks the end of almost a thousand years of striving after a 'humanised' art, in which the Mediterranean cultures had outshone all their more easterly predecessors. The most obvious way of explaining this important change is to ascribe it to a general decline in artistic skill, a result of the increasingly unstable political and economic conditions in the decadent Roman Empire. According to this theory, the growing resemblance between official Roman art and provincial art showed that official art was itself becoming provincial. Artists no longer trained to paint or carve a lifelike human figure, to study the characteristics of an individual face or to create the illusion of three-dimensional space in a painting or relief would inevitably produce the flat abstract compositions and stiff impersonal figures which had all along marked the less pretentious works in the provinces.

There is undoubtedly some truth in this assertion. The average Late Roman work of art betrays considerable carelessness; a decline in technique and craftsmanship resulted in simplification amounting to crudity. On the other hand it is quite clear that there were some who found new possibilities and positive merits in this 'provincial' style. If Classical ideals were abandoned, it was not just because they ceased to hold interest: artists began to pursue new objectives for which 'sub-Antique' art offered more adequate forms of expression. A work like Projecta's casket, with its strongly Classical character, is not the best example of the new and positive tendencies in Late Roman art; these are very much more clearly visible in an ivory panel with the apotheosis of an emperor (fig. 5), also probably a Roman work of the later fourth century. Both in style and spirit, this carving marks the dawn of the Middle Ages in the late pagan art of Rome. There are Medieval elements even in its subject-matter. In the lower half of the panel we see an emperor, whose identity has never been definitely established, seated in a carriage drawn by four elephants. In the upper half, the same person is being carried to heaven – represented by signs of the Zodiac, the sun-god and a number of busts of uncertain significance – by two naked winged genii. In the centre is a veiled pyre, from which a naked deity drives heavenwards in a chariot, escorted by two eagles. Not all the details of this panel have been adequately explained, but it is clearly an elaborate representation of the emperor's progress to the next world. It illustrates the belief in a life after death which, although in existence throughout the Classical period, had never taken such definite

shape and had never been the subject of so much interest and speculation as in this late period. The neoplatonic and Mithraic beliefs which dominated philosophy and religion in Late Roman times were centred in the hereafter, and the panel exemplifies the interest in the supernatural and transcendental which had taken possession of the Classical world and was one of the signs heralding the end of Classical Antiquity.

The style of this carving, although at first sight totally decadent, contains novel elements. There is a complete and significant neglect of the third dimension: the figures, although meant to be at varying distances from the spectator, all appear in one plane, and, while an attempt was made to render in perspective the canopy surrounding the emperor, the illusion of depth is destroyed by the alignment of the elephants' feet with the wheel of the carriage in the foreground. Equally significant are the loss of individual characteristics in the faces, the staring eyes and the awkward poses of the figures. All these features are familiar from 'sub-Antique' art; if they now begin to occur on works clearly of an official character, it is not – or not just – because they require less skill. There is a positive intention behind their use. For one thing, the absence of perspective and the simplified composition and figures focus attention on essentials: the artist's main interest was in his story, he was anxious to convey a particular message, and he has invited us to concentrate on this rather than on details of form. In Classical works of art we always find a perfect balance between content and form; the loss of this balance marked a new stage in art history, a stage in which art had become a vehicle for the propagation of certain doctrines.

Yet it would be wrong to say that our artist simply neglected formal values: there is in this carving an almost deliberate protest against realism. The sculptor has made it clear that he had no confidence in formal beauty or naturalism. He has disregarded the laws of nature; he shows that he was not interested in such things as three-dimensional space and the anatomy of the human body. For these he has substituted other values. His concern was the abstract relationship between things rather than the things themselves. Instead of a naturalistic scene he has given us a solemn assemblage of persons, with the emperor as the central power. A composition arranged like a geometric pattern on a single plane with a blank background of infinite depth is removed from the sphere of actual life and has a spiritual significance, a symbolic and transcendental character. There are, therefore, new and positive qualities in this so-called decadence which are closely bound up with the moral and religious changes the subject-matter of our

FIGURE 5

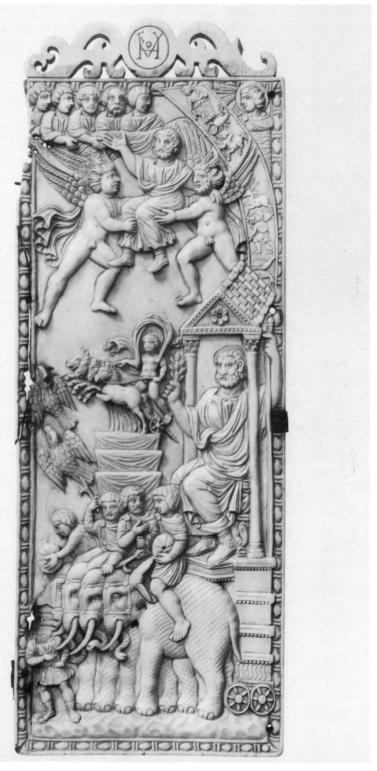

Ivory with the apotheosis of an emperor.
Probably carved in Rome, late fourth century. Height 30 cm.

panel reflects. The tendency of the age was to seek an escape from the material world, and men found refuge and consolation in the spiritual.

The scene is not merely a statement of such values, however. Perhaps its most significant aspect is its strong and direct appeal to the spectator. A Classical work of art is entirely self-contained: figures on a Greek relief turn to each other, unaware of our presence and independent of it. The scene on the ivory, on the other hand, is presented to us ceremonially: all the principal figures are conscious of our presence, and the whole composition is spread before us and is meaningless without a spectator. Not only had the outlook of the artist changed, then, but also his function. He was making a direct appeal to his public, he had a definite message to convey, and he was also aiming at a definite psychological effect, as the solemn and awe-inspiring figures clearly show. An entirely new art was in the making here, differing from Classical art both in its approach to the outside world and in its relationship to the spectator. The style of 'sub-Antique' art was adopted because it offered these new aims more adequate expression; it was adapted to serve a new purpose.

The full result of this revolutionary tendency did not become apparent until much later: its ultimate outcome was the art of the high Middle Ages. It was left to the painters and sculptors of the twelfth and thirteenth centuries to discover the consummate form for the spiritual and transcendental, and it was the Medieval Church which perfected the use of art as a didactic instrument and as a vehicle for the propagation of the faith. The rigid solemnity to which our sculptor aspired eventually materialised in the figures of Christ in Majesty enthroned over the porches of Medieval cathedrals. The motionless impersonal faces monotonously arrayed in the upper zone of our carving had as their successors the rows of saints in Medieval paintings and reliefs. Roman art of the third and fourth centuries initiated this movement, and therein lies its greatest significance. It should be noted that the decisive turn took place at a time when there was still very little Christian art. Classical art became 'medieval' before it became Christian: the new creed was not a primary cause of the change. The art which the Christians took over from their pagan contemporaries was already on its way towards the Middle Ages.

Having thus indicated, however briefly, the twofold origin of Early Christian art, we must now describe its development between the fourth and eighth centuries. But since not just Early Christian but all Medieval art was derived from the two sources described – the Classical and the anti-

Classical – a few general observations bearing on the whole of our subject should first be made. There was a struggle between the two elements throughout the Early Medieval period, and not until its end was harmony reached. Most of our examples bear the marks of conflict and uncertainty, which sometimes makes the approach to them a little difficult. Again and again one feels tempted to judge them by Classical standards, and yet if such standards are applied it is only too easy to discover all sorts of mistakes and misunderstandings. It must always be borne in mind that the Medieval artist, even when he appears to have been imbued with Classical taste, had little direct contact with nature: if he clung to Classical traditions, he did it by copying works of the Classical period or by following the technical processes of his forefathers, not by studying nature and drawing from life as they had done. The natural world held little intrinsic interest for him; to that extent the break which came about in the Late Antique period was decisive and final. The copying of models had an important role throughout the Medieval period, and Classical tradition in Early Medieval art generally meant that figure-types created by Greek and Roman artists were taken over as convenient ready-made formulae. This second-hand Classicism is very often the most prominent feature of Early Medieval art, and yet it is hardly ever a clue to its real importance.

The development in the direction of a truly abstract art, on the other hand, was far from uniformly progressive, and this again makes the art history of the Early Middle Ages difficult to understand. Our bust from Palmyra (fig. 1), dating from the second century, anticipates statues on Romanesque cathedrals to an astonishing degree. A figure in a Byzantine miniature of the tenth century (pl. 9), however, reproduces Classical models so faithfully that it is difficult to believe that almost a thousand years separate it from the period of Pompeian wall-painting. Thus the pendulum swung constantly between the two extremes of a straightforward naturalistic and a geometrical didactic art. The two tendencies existed side by side, and it is not always easy to recognise the gradual progress which was made towards the final goal.

The present chapter deals with the first stage only of this evolution, but different parts of the Mediterranean world demand individual attention: the Roman Empire had fallen to pieces, and during the Early Christian centuries there emerged regions with individual characters finding expression in individual artistic styles. In the struggle between Classical and anti-Classical tendencies, the various regions of the ancient world made very different contributions.

In the Latin area, Italy was still the focus of cultural life, although Spain and southern France also took part in the development. It would be wrong to assume that after the transfer of the imperial residence from Rome to Constantinople early in the fourth century the influence of Italy immediately disappeared. The first real setback came with the barbarian invasions of the fifth century, which not only hindered cultural activities in Italy but also led, at least for a time, to an increasing dependence on the protection of Constantinople. By the sixth century Italy was, in fact, little more than a province of the Eastern Empire, but the subsequent quest for independence made for a steadily widening rift between Rome and the East during the next two hundred years, and for the gradual assertion of a distinctive style in art.

Italy had been chiefly responsible for the adoption of those abstract principles which, as we have seen, were a death-blow to truly Classical art. It has often been said that Roman artists did not develop this style independently but under strong eastern influence. It has also been suggested that Italy was never really a home of Classical art in the same sense as Greece had been, and that the return to abstract art was facilitated by the 'Italic spirit' inherited from Etruscan and Republican times and only temporarily overshadowed by the Hellenistic tastes of the ruling class in Rome during the first two centuries of the Imperial era. The most important factor, however, is that Rome was still the centre of the world at the time the decisive changes in intellectual outlook were taking place. This is why the gradual absorption of 'sub-Antique' elements into the official art of the Empire can be seen more clearly here than in any other region. By the time Christianity was given official recognition in the year 313, the most representative works of art in Rome were being executed in a frankly abstract and 'primitive' style; the reliefs made immediately after that date for the Arch of Constantine, with their two-dimensional compositions, monotonous rows of block-like figures owing more to spiritual than to naturalistic principles, and the symmetrical arrangement and hieratic qualities of at least some of the scenes, are an even more striking instance of 'medievalism' in Italian fourth-century art than is our ivory panel. These characteristics subsequently asserted themselves again and again; rigid symmetry, flat composition without perspective, and clear linear design may be described as typically Latin characteristics. The development is far from straightforward, however: there were frequent returns to a more Classical manner, for the Hellenistic tradition in Italy was strong and powerful. The country was continuously subjected to the influence of

other styles from the East, though, especially in the centuries of political dependence, and therefore offers typical illustrations of the continuous struggle between Classical and anti-Classical tendencies which is such a feature in the history of Early Medieval art.

Not all the stages of this development can be traced here, but attention must be drawn to the first important revival of the Classical spirit, towards the end of the fourth century, after the abstract and 'transcendental' vogue of the Constantinian age. Even under Constantine, the Classical tradition had probably not entirely died out; it came more to the fore, however, in the second half of the century. There is a parallel in general history in figures like the emperor Julian the Apostate (361–363). There was still a powerful minority of pagan aristocratic families in Rome, who now made a point of displaying an artistic taste founded on the masterpieces of the Classical period. This 'renaissance' probably started in the pagan circles, but as even conservative aristocrats gradually adopted Christianity their traditional taste became typical of pagans and Christians alike. No object illustrates this point more clearly than Projecta's casket (fig. 2); Projecta married into a family prominent in the pagan aristocracy, and although she and her husband were Christians the style of her casket bears the marks of the strong pagan traditions in the family. Even when commissioning a painting or sculpture, the subject-matter of which would bear witness to their new religion, such aristocratic patrons insisted on the Classical standards of form being maintained. A large group of works executed in Rome around the year 400, while Christian in content, is none the less Classical in style. For a short time at least, Classical beauty and refinement were introduced into Christian art.

The influence on Christian subject-matter was, however, profound and permanent. Hitherto Christian art had been largely symbolic, and even biblical scenes had been represented only for the sake of their symbolic value: the Sacrifice of Isaac, Daniel in the Lions' Den, Noah and the Ark, Jonah and the Whale and the Raising of Lazarus had been little more than symbols of resurrection and salvation. The artist had confined himself to principal features serving to impress on the spectator the moral of the story, and Old and New Testament scenes had often been mixed, because the essential meaning was the same in both. But now we begin to find separate Old and New Testament narrative cycles, illustrating consecutive episodes in a series of scenes with a great amount of realistic and even anecdotal detail; interest in the lives of biblical persons and in biblical events began to replace the interest in hidden meanings. It is hardly an

FIGURE 6

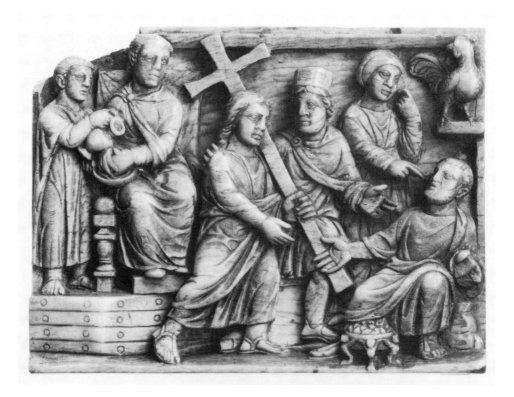

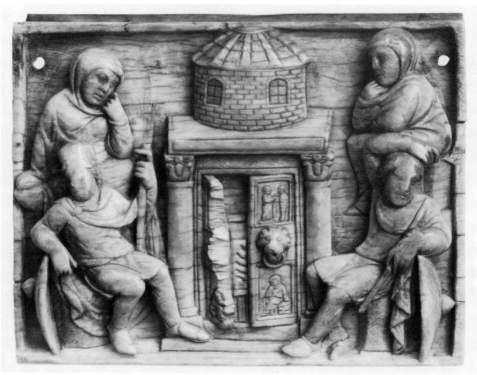

Four sides of an ivory casket with scenes from the Passion.

FIGURE 6

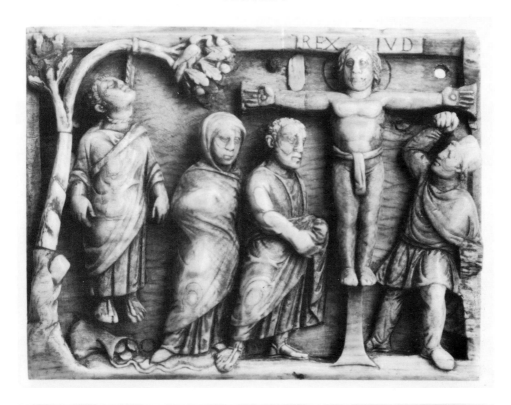

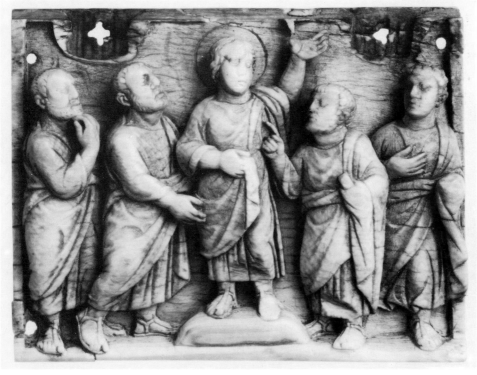

Probably carved in Rome, early fifth century. Width of each panel 10 cm.

accident that this return to the descriptive manner of the historical reliefs of the Romans coincided with the introduction of a more Classical style in Christian art.

These historical cycles from the Bible were to continue as a steady and continuous tradition throughout the Middle Ages. The earliest extant cycle of scenes from the Passion executed in the narrative manner appears on panels from an ivory casket (fig. 6); earlier representations had been less detailed, and the Crucifixion had never been represented realistically but only suggested, by means of a cross guarded by two soldiers, for instance. The panels from the casket not only have the scenes enriched by a great deal of narrative detail, such as the sack with the thirty pieces of silver cast away by Judas, but also include what must be one of the earliest representations of Christ crucified. The panels also illustrate, to some extent, the Classical revival in style. The soft and fleshy character of the bodies with their gently rounded outlines and delicately modelled draperies, the illusion of depth in the scene of Peter's denial, and the languid pose of some of the figures – the guard to the right of the tomb, for instance – all combine to give the reliefs a more Classical appearance than the apotheosis ivory (fig. 5) has. They are, however, by no means the most typical specimens of this Classical interlude, and in many respects they exemplify the opposite tendencies. For instance, on the Crucifixion panel no attempt was made to represent Christ or Judas as convincingly hanging bodies, some of the other figures are unduly clumsy, both in proportions and pose, and two of the scenes show a marked tendency towards a symmetrical composition against a plain background.

The Classical 'renaissance' was short-lived. In the course of the fifth century abstract elements again prevailed in western art, and in some ways our panels foreshadow the linear and structural tendencies which henceforth characterised Italy's role in the general evolution of Early Medieval style. Although new factors continually appeared, largely as a result of Byzantine influence, it was this abstract geometric style which finally prevailed in Italian art.

From the western Mediterranean we turn to the East. All along the shores of Asia Minor, Syria and Egypt the Greeks had established a firm hold at the time of their political hegemony. Some of their cities, such as Ephesus, had at an early date become great centres of commerce and industry as well as of religious, intellectual and artistic life. More large cities had grown up under the successors of Alexander the Great, cities which surpassed Athens in splendour and importance and preserved their

metropolitan character even after they had fallen under Roman rule; Antioch and Alexandria became the most famous.

These centres played a leading part in the later stages of the evolution of Greek art. Greek taste and Greek style had taken root there, and when the Classical style began to degenerate in the third and fourth centuries artists in the eastern Mediterranean cities did not carry the new abstract and primitive tendencies to quite the same length as their Roman contemporaries. The Mediterranean world was a unit, however, and in that critical period Classical ideals were abandoned in the East as well as the West; the Roman rulers exerted a standardising influence, moreover, and official work initiated by the imperial administration showed the new abstract tendencies wherever it appeared. In fact the eastern cities were probably instrumental in adapting the 'sub-Antique' art of their own inland regions to the requirements of official imperial art, and works like the porphyry sculptures commissioned by the Roman rulers but mostly made in Egypt were among the first to show unequivocally the new abstract hieratic style. In the unofficial art of Alexandria and the other large cities, on the other hand, the lively and colourful manner of Hellenistic art persisted. It is found in the decoration of mosaic pavements, in the ivory and bone carvings which ornamented many everyday objects, in metalwork and in textiles. The survival of this style in the Christian as well as the secular art of the East is shown by works like the Cotton Genesis (fig. 7, pl. 3) and an ivory diptych leaf with the figure of an archangel (fig. 8).

The Cotton Genesis, the earliest illustrated biblical manuscript known from the Greek world, is almost universally regarded as the work of an Alexandrian painter of the fifth or early sixth century. Unfortunately, all that has survived of the rich cycle of illustrations it once contained is a series of half-burnt fragments, but some of these still clearly show the sketchy impressionistic manner of Classical painting. There are figures with faces indicated only by a few black strokes, lively expressive movements, and light backgrounds of transparent colours which give an illusion of depth and atmosphere, while buildings in perspective and figures standing half-hidden behind those in the foreground contribute to the impression of depth. It is true that the artist, no less than his counterpart in the West, had lost direct contact with the natural world. Many figures are much too large in relation to the buildings surrounding them and, for the sake of simplification, are often shown frontally; the outlines of houses have been made to coincide with the frame. As an heir to the true Hellenistic tradition, however, the artist still tried to provide a naturalistic

31

and vivid illustration of his story, and, unlike his western contemporaries, he refrained from changing his figures into sculpturally conceived masses and did not try to convert a free and casually grouped scene into a rigidly structured composition; a comparison of the Cotton Genesis with the Passion ivories (fig. 6) illustrates the difference.

The contrast between East and West became more and more marked as time went on. The archangel ivory (fig. 8) shows that Greek artists were still endeavouring in the sixth century to give their Christian figures the appearance of Greek statues. Here again, forms are not correct in the Classical sense: the feet rest on a flight of steps behind an arch, while the hands and wings suggest that the figure is standing in front of that arch. On the other hand, the carefully modelled body, the delicately carved drapery and the archangel's calm, detached expression suggest that the artist was none the less anxious to capture the overall effect of a Classical relief.

The Hellenistic tradition in the eastern Mediterranean was a vitally important factor in the general evolution. It has often been said that it was a feature not of the region in general but of Alexandria alone, which is supposed to have remained the sole focus of Hellenistic civilisation and style into Late Roman and Byzantine times. Since, however, we are not really able to distinguish between the Late Antique style of Alexandria and that of cities like Antioch and Ephesus, which also had a strong Hellenistic tradition, the style should be attributed to the eastern Mediterranean in general. In any case, there is evidence that every one of these cities had lost at least some of its importance by the fifth century; the centre of gravity in the eastern world had by then shifted to the new capital of Constantinople, and there is reason to believe that the workshops which continued to minister to the most refined Hellenistic taste amid the ruins of the Classical world were there, in the neighbourhood of the imperial court. Constantinople attracted the best artists from the eastern Mediterranean and, by the sixth century, when the Byzantine Empire reached the height of its power and expansion under the emperor Justinian (527–565), the city was adorned with buildings of unparalleled splendour; no other city had anything to compare with Justinian's greatest architectural triumph, the church of Hagia Sophia. By that time Constantinople had undoubtedly become the leading city in the East, and the provincial cities began to depend on the influence of the capital. A figure like our archangel may therefore be described as typically Byzantine work, either from Constantinople itself or from a provincial school working in the refined and aristocratic if somewhat staid and academic style favoured in the metropolis.

FIGURE 7 FIGURE 8

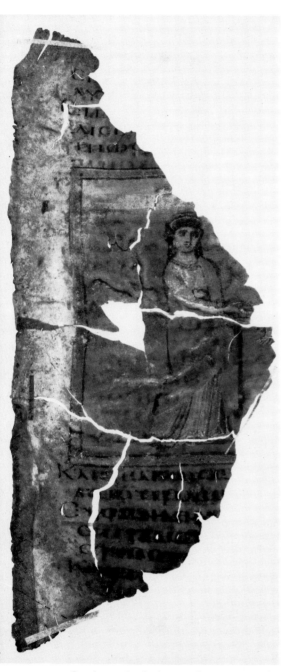

Sarah, on the fragment of
a leaf from the Cotton Genesis.
Probably from Egypt,
fifth or early sixth century. Width 6·5 cm.

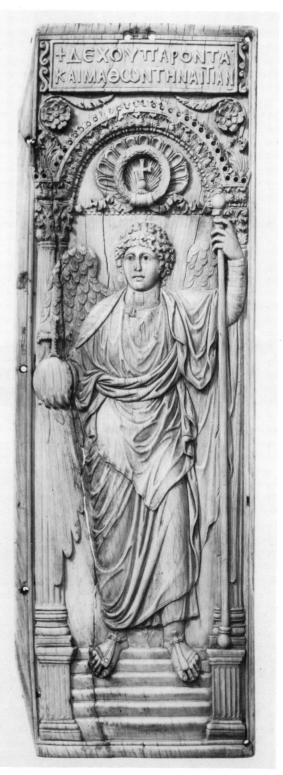

Leaf of an ivory diptych with the figure of an archangel.
Probably carved in Constantinople, sixth century. Height 41 cm.

FIGURE 9 FIGURE 10 FIGURE 11

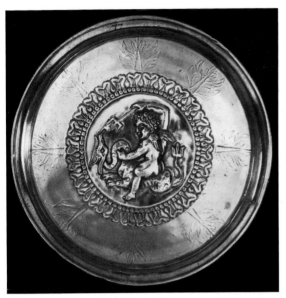

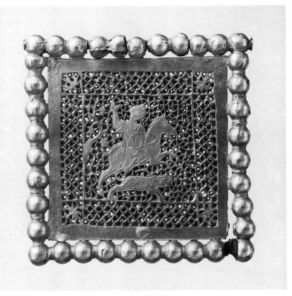

Silver dish with a Cupid fighting a sea-monster.
Byzantine, seventh century. Diam. 13 cm.

Gold ornament with hunting scene, from Asia Minor.
Fourth century. Height 5 cm.

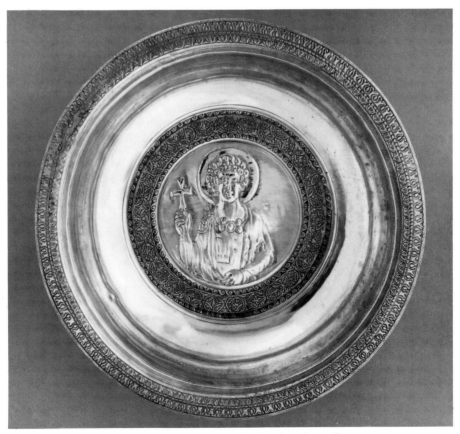

Silver bowl with St Sergios or St Bacchos, from Cyprus.
Probably made in Constantinople, seventh century. Diam. 24·5 cm.

The Classical leanings of the court are particularly evident in Byzantine silver vessels. Many of these bear imperial control-marks which show that they were made, if not in the capital itself, at least under the supervision of the government. They are often decorated with embossed reliefs, and even as late as the seventh century the subjects were often chosen from Classical mythology (fig. 9). They are executed with so complete a knowledge of Classical style that they were long thought to belong to the second or third century. Even though its subject-matter is Christian, a silver bowl found in Cyprus (fig. 10), with control-marks probably of the period of Constans II (641–668), is to some extent Classical in appearance.

The eastern Mediterranean coast, however, was not only a great centre of Hellenistic culture: it was also very close to regions in which 'sub-Antique' art had flourished in Roman times, and we therefore find, side by side with forms showing the survival of a comparatively pure Classical tradition, many stylistic features belonging to the anti-Classical current in Late Antique art. A fourth-century gold plaque (fig. 11), for instance, has as the background to a hunting scene an openwork pattern owing its effect not to any particular ornamental motif but to the glittering interplay of light and shade. The figures, instead of being firmly supported by a solid background as in Classical art, float in indeterminate space. A 'sub-Antique' technique of ornamentation has been used to achieve an effect of vagueness and transparency, an effect in which Byzantine artists delighted and which became an outstanding feature in many of their buildings, mosaics and reliefs.

A similar combination of Classical figures with anti-Classical ornament is seen in fragments of a seventh-century Byzantine illuminated Gospel (fig. 12), where arches surrounding the Eusebian canon-tables are covered with motifs quite unknown in Classical art, while little medallions contain busts of saints in the best impressionistic tradition of Hellenistic painting. The ornament is anti-Classical, not only because it consists of rows of separated flowers and leaves – a feature unknown to the Greeks and Romans though very common in the 'sub-Antique' art of eastern Syria and Sassanian Persia – but also because of its strange relationship to the architectural framework. Architecture and ornament have exchanged functions: the decoration, instead of being subordinate to the columns and arches, is the predominant feature, while the architecture has been reduced to a system of faint outlines which look like the conventional frame of a purely abstract pattern.

This anti-Classical influence is not confined to ornament. It is also

FIGURE 12

Canon-tables from a Byzantine Gospel-book.
Possibly made in Constantinople, seventh century. Height 21·5 cm.

FIGURE 13

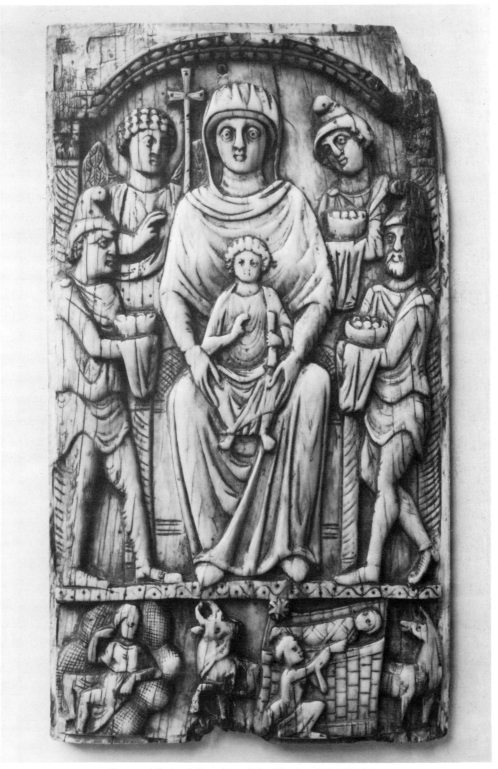

Ivory with the Adoration of the Magi and the Nativity.
Probably carved in the Holy Land, sixth century. Height 21·5 cm.

conspicuous in certain figure-compositions and explains what we have come to regard as the most typical feature of Byzantine art: long rows of saints, with large black eyes and a gloomy air, standing stiffly against a gold background, facing the spectator, and the equally stiff and solemn figures of emperors in heavily jewelled garments, all hieratic and somewhat barren representations. We know this art from mosaics in Ravenna, which, dating from Justinian's time, when the city was the seat of the Byzantine exarch in Italy, appear to reflect – not unfaithfully – Constantinopolitan works of the time; although contemporary mosaics and paintings have not survived from the eastern capital, it is hardly conceivable that the famous mosaics in the church of San Vitale in Ravenna, showing Justinian and the empress Theodora in solemn procession, differed greatly from pictures of similar subjects in the churches of Constantinople. We also know this solemn hieratic style from some of the eastern ivory carvings of the sixth century, especially the so-called consular diptychs, and the same tendencies can be seen in an ivory plaque with the Adoration of the Magi (fig. 13). This scene, usually represented in a lively, natural manner with the Magi approaching from one side and the Virgin seated in profile on the other, has here been turned into a statuesque group. The figures are symmetrically distributed on either side of an austere Virgin seated facing the spectator, on whom her eyes – large and staring like those in contemporary mosaics – are firmly fixed. A charming episode from the childhood of Christ has been turned into a severe and awe-inspiring ceremonial. Works like this illustrate the other side of Byzantine art. From its territories to the east, Constantinople borrowed the elements of hieratic figure-style and of rich and gorgeous but at the same time rigid and abstract ornament.

This aspect of Byzantine art is perhaps more familiar than the Classical one, but it is important to note that the two styles existed side by side. Although it never succeeded in ousting the Greek tradition, the abstract style occurred all along the eastern Mediterranean coast, and it is possible that its grip here was in places even stronger than in the capital. It is in fact in Palestinian monuments that narrative subjects like the Adoration of the Magi were turned into hieratic images, and our ivory panel may well have been carved in the Holy Land rather than in Constantinople. It is, nevertheless, a typically Byzantine work: the artist was familiar not only with the hieratic but also with the Hellenistic style, for beneath the solemn Adoration scene he represented the Nativity in a much less stiff and more Classical manner. Nothing could show more clearly the duality of styles prevailing in these regions. On the borders of two worlds, the Greek and

the oriental, Byzantium evolved two entirely different modes of expression, delighting in reminiscences of the lifelike, free and delicate art of the Greeks and at the same time adopting the cold splendour and gloomy austerity of Asiatic art, appropriate to an age of strict political and cultural organisation and of intellectual and religious coercion.

Finally, we look briefly at the third region to play an important role in these early centuries. Behind the coastal belt of the eastern Mediterranean, a number of provinces developed artistic styles of their own in Early Byzantine times. Inland Asia Minor had its own art, differing from that of the Aegean shore, while Syria and Palestine had their local characteristics, and a particularly distinctive regional style can be seen in Early Christian works of art from the Nile valley. Further from the Mediterranean, Mesopotamia and Armenia each had a highly developed art of its own. The characteristics of these individual styles are most evident in architecture, but painting, sculpture and the minor arts also had a striking local flavour.

Typical of such Early Byzantine provincial art are the illuminated manuscripts of inland Asia Minor – particularly Cappadocia – and of Syria. Manuscript illumination in these areas was largely in the hands of monasteries, which were centres of learning and hotbeds of theological controversy. To the monk, the content was the main interest, and books were illustrated chiefly to make the text more intelligible and the argument more convincing; anything not essential for elucidating the point of a story was omitted. There are no pictures like those in the Cotton Genesis, with their Classical apparatus of scenery and frame; the figures were painted directly on to the parchment and in many cases do not even have a compartment to themselves but appear in the margin of the text as a kind of pictorial commentary. Their style is derived from Classical models, but the painters – not bound by court etiquette like their colleagues in Constantinople, and less afraid of innovations – did not hesitate to vary the appearance of a person to accord with his function in the scene, or to sacrifice correctness of design to vigour of gesture and action. The charm of the figures lies in the impassioned expressiveness of their eyes and hands; some are not in colour but merely line-drawings, the pen bringing out their expressive character even more strongly than the brush. The tradition survived into later centuries (fig. 27), when it was practised even in the capital by certain monastic workshops.

While painters in Asia Minor and Syria developed the element of graphic expressiveness contained in the Hellenistic style of Byzantium,

FIGURE 14

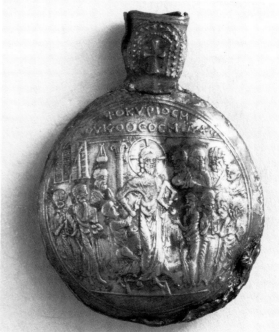

Pewter pilgrim-flask with the Holy Women at the Sepulchre and the Incredulity of Thomas.
Probably from the Holy Land, sixth century. Height 7 cm.

the hieratic style, as we have seen, was favoured in the Holy Land. Pilgrims' flasks for holy oil and water, reliquaries, and other objects connected with the cult of holy places were frequently decorated with scenes from the life of Christ, characterised by symmetrical composition and stiff monumental figures (fig. 14). Although not confined to the Holy Land, this style appears to have been in particular favour there.

The most distinctive local art, clearly distinguishable from that of all other regions, grew up in Egypt. The Nile valley, although nominally under Byzantine domination, stretched too far south into the African continent to be effectively administered by the central government. The Egyptians had their own form of Christianity, and their continual disputes with the official Church led in the fifth century to the establishment of an independent national Church known as Coptic, a term which is also used to describe the art of the Christian period in Egypt. The peculiarities of this art had begun to develop even in pagan times. Egypt had been thoroughly hellenised when under Greek domination, and Hellenistic art had become the property of all: houses were full of terracotta statuettes in Greek style,

textiles were colourfully decorated with Cupids and other subjects of Classical origin, and buildings were adorned with foliate friezes and mythological reliefs. As the art of the populace, this decorative style survived side by side with the official work carried out on behalf of the Roman and, later, the Byzantine rulers. As long as Alexandria continued to play its part as a guardian of genuine Greek culture, the quality of the Hellenistic art remained fairly high, notwithstanding the anti-Classical and 'sub-Antique' elements found at an early date in mummy portraits and other products of popular art. As the influence of Alexandria gradually weakened, however, the provincialised version of Hellenistic style asserted itself more and more.

Coptic art owes its largely decorative character to its origin in the everyday art of Graeco-Roman Egypt; even in Christian times the Egyptians decorated their churches with foliate designs, animals and geometric patterns, and as late as the eighth century garments were still being adorned with Cupids and other pagan motifs in bright colours. Christian figure-subjects were also introduced in paintings, sculpture and textiles, of course, but even they were often made to serve a largely decorative purpose. Coptic art, therefore, was much less an instrument of instruction and propaganda than was the Christian art of Italy and Constantinople. In its mainly decorative character and lack of literary content it curiously foreshadows Islamic art, which was to achieve some of its greatest triumphs on Egyptian soil. The stylistic development consisted in a gradual elimination of Classical and naturalistic forms. Abstract regularity, symmetry, repetition and a preference for the full-face view of the human figure, features which had been characteristic of the 'sub-Antique' art of the provinces, now helped to transform the Hellenistic heritage, and the process was intensified by influences from the adjoining Asiatic countries.

A seventh-century tombstone from Egypt (fig. 15) shows Coptic decorative art in its highly conventionalised stage. In the foliate scroll and even in the bird the Classical tradition can still be detected, but all natural forms have been completely subordinated to an ornamental composition, and the abundant use of the contrast between light and shadow has produced a carpet-like pattern covering the whole slab, individual motifs of the decoration taking a secondary place; similar tendencies were evident in the 'sub-Antique' art of the Holy Land many centuries earlier (page 20). Thus we see how, in the furthest provinces of the Byzantine Empire, Hellenistic art was gradually adapted to a taste rooted in old local traditions.

The increasing subordination of organic forms to a decorative design is particularly clear in textiles, which the desert soil of Egypt has preserved in great numbers. Until the sixth century the Hellenistic element was still very strong, and artists endeavoured to make us forget the regularity of the texture by skilfully weaving a naturalistic figure into the system of warp and weft. But a silk panel of the seventh century (pl. 4) shows how the shapes of men and animals have been adapted to the straight lines and right angles of the texture: all the outlines are angular, and details of faces and garments have been simplified accordingly. Moreover, the weaver exploited the repetitive capability of the loom to confront his horseman and accompanying animals with their mirror images in an almost heraldic manner. Even biblical scenes were sometimes treated in this fashion on Coptic textiles, and it is clear that they were regarded as decoration rather than illustration. In the case of textiles it was possibly Persian influence which helped bring about the complete transformation of Classical models.

These few examples must suffice to characterise the various regional schools which developed in the furthest reaches of Byzantium. Despite the great variety of styles, there is a justification for including them all under one heading – their common relationship to Constantinople. We have seen how Constantinopolitan art penetrated the provinces, and in some regions we find art which might have been produced in the capital, so little does it differ from the work of artists there. Contrasting with this international element are the local and indigenous styles of the various provinces. There is not always a clear division between the international and the regional style, for Constantinopolitan productions were often imitated by local craftsmen; on the whole, however, we can say that regional elements represent the art of the people as distinct from that of the court and that, where cultural activities were largely in the hands of monasteries, as in Asia Minor, Syria and Egypt, the local art was often bound up with the monastic community.

A further unifying factor was the attitude of the artists towards the international art of Late Antique and Early Byzantine times. The regions developing characteristic local styles were for the most part those in which 'sub-Antique' art had flourished in the first centuries after Christ, and the approach adopted by the artists to Mediterranean and, particularly, Constantinopolitan art was much the same as the attitude of their forefathers had been towards Classical art. Most types and motifs, whether figures or conventional ornament, were derived from Mediterranean art, which provincial craftsmen imitated and at the same time interpreted in their

FIGURE 15

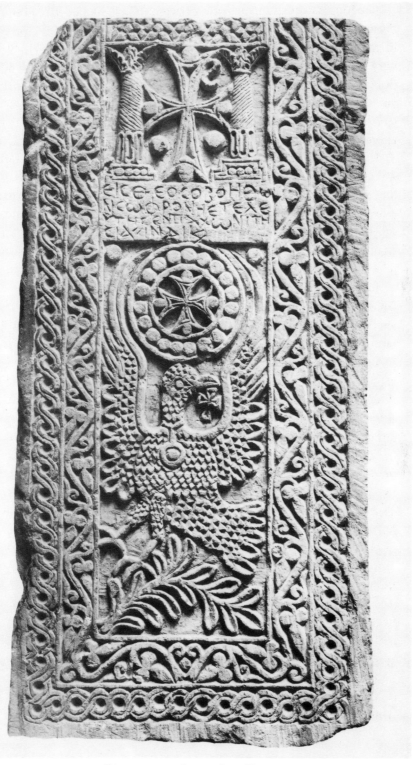

Limestone tombstone from Egypt.
Coptic, seventh century. Height 81·5 cm.

own peculiar way. They would emphasise one element and concentrate on a particular point, such as decorative design or expressive human gestures; the models were simplified and features of local origin added. The result, however unique to a particular region, is invariably characterised by an increase in stylisation and abstraction. At the same time the provincial styles broadly reflect the development in the Byzantine world as a whole. And in their turn they influenced not only Byzantine but also western art.

Even this brief survey has shown how many different styles developed side by side in the Late Antique and Early Christian period, and in how many different ways the various parts of the Empire reacted to the break-up of Classical art. At the heart of the ancient world was Constantinople, which remained closest to the Classical tradition and became its most faithful guardian. In both the East and the West, however, the opposite tendencies gained more and more ground and developed in various ways. Even Constantinople did not remain uninfluenced: it adopted many elements of abstract art, especially from its eastern provinces.

During the seventh and eighth centuries the period of the absolute pre-eminence of the Mediterranean countries, united by their Classical heritage and to some extent by Byzantine rule, gradually came to an end. In Constantinople itself, soon after the glorious reign of Justinian, there was a marked decline in both the quality and quantity of artistic production. At first it appeared to be merely a hiatus after the immense efforts of the preceding decades, but political and economic difficulties were soon to arise, placing serious obstacles in the path of artistic evolution for many centuries to come. First came Persian invasions, late in the sixth and early in the seventh century, which resulted in the temporary loss of Syria, Palestine and Egypt. Then, in the course of the seventh century, an even more powerful enemy appeared – Islam. In less than a hundred years, most of the Asiatic provinces of Byzantium, the whole North African coast and even Spain were absorbed by this new and entirely different civilis-ation. The crisis in the Mediterranean world was aggravated when the antagonism between East and West, represented by the Emperor and the Pope respectively, flared up; this had an important bearing on art history, since this time the quarrel was over the admissibility of pictures in Christian worship, the so-called Iconoclastic controversy.

As a result of these various events Constantinople, while remaining the largest and richest city in the world, ceased to be its unchallenged centre; the Byzantine Empire, greatly reduced in extent, became but one power among others. From the art historical point of view Byzantium sustained

an even greater loss: for more than a century it became the champion of Iconoclasm. The eighth century, therefore, was a critical period in the history of Mediterranean art, the more so as a new star was rising north of the Alps: the Frankish kingdom, soon to be raised to the status of an empire by its greatest ruler, Charlemagne. Thus began the second phase in the evolution of Medieval art, in which the north took the lead.

II

⎯⎯⎯

CAROLINGIAN ART

When Charlemagne embarked on his ambitious scheme, a revival of the Roman Empire and Roman civilisation under Frankish leadership, there was already north of the Alps an artistic tradition of long standing, largely the heritage of the Migration Period (between about 400 and 600). This northern art was the opposite of Mediterranean art in almost every respect; associated in its origins with wandering tribes, it was almost entirely confined to such portable objects as personal ornaments, weapons and implements and did not include monuments such as stone buildings, fresco paintings, mosaics or large-scale sculpture. Goldsmiths' work, enamelling, the casting of small bronze objects and the carving of bone were the crafts at which the northern artists excelled.

Their aim was not the representation of a particular subject, religious, historical or otherwise, but abstract ornament. Whether for these people the ornament on a weapon or a necklace still retained the magical power which had been the main reason for its original creation in a more primitive culture or whether it should be regarded as the outcome of a highly developed aesthetic sense is doubtful, but in any case the barbarians of the north held aloof from the naturalistic art brought to perfection by the Greeks and Romans and inherited by the Christians in the Mediterranean countries. While in Italy and Byzantium sumptuous churches were built and decorated with figural mosaics and reliefs and manuscripts were illustrated with figures and historical scenes, northern artists were absorbed in the invention of rich and increasingly fantastic ornament with which to cover their brooches and pins, their buckles and strap-ends and their drinking-horns and sword-hilts. Some of this ornament was purely geometric, with designs such as spirals, zigzags and step-patterns, but the artists also used animal figures and even borrowed portrait-busts and horsemen from Roman coins. They transformed these naturalistic motifs almost beyond recognition, treating them as abstract patterns, first splitting them up and then mixing their details in the most illogical manner (fig. 16). Animals of

FIGURE 16

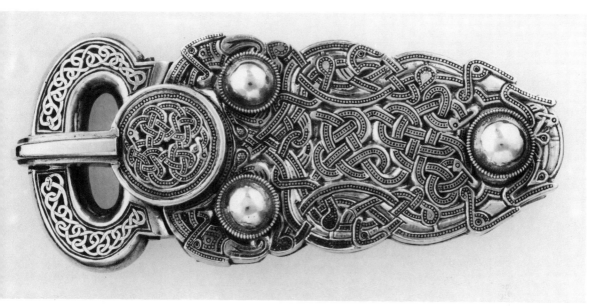

Gold buckle from Sutton Hoo.
Early seventh century. Length 13 cm.

fantastic shape would be juxtaposed in rows, their limbs interlaced to form intricate all-over patterns.

With the spread of Christianity in the seventh century the first contacts with the Christian art of the Mediterranean were established. In Merovingian France, Ireland and England stone churches of southern type began to appear, and large-scale sculpture in stone was introduced and widely applied on the numerous high crosses of Ireland and Northumbria. The most important of the crafts introduced by the missionaries were the writing and illuminating of books; the Gospels were the moving force behind the Christian missions, and elaborate pictorial illustration was their almost indispensable accessory. Under the patronage of the Church all the principal Mediterranean crafts were thus established in the north, but they had only limited influence on style: the native tradition not only held its ground in the secular field but even became the principal source of inspiration for the decoration of churches, sculpture and manuscripts. At an early date, however, efforts were made by Christian artists in the north to emulate Mediterranean models. The earliest crosses of Northumbria, for instance, show Classical types of figure and ornament handled with astonishing skill. The barbarian spirit soon reasserted itself, though, and even took over the illumination of manuscripts.

47

FIGURE 17

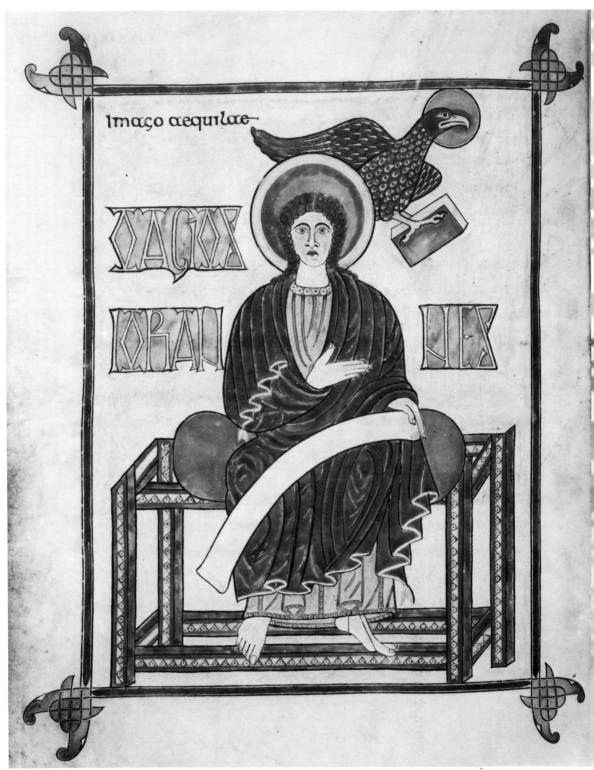

Evangelist portrait from the Lindisfarne Gospels.
Northumbrian, late seventh century. Height of panel 23·5 cm.

This point is well illustrated by miniatures in the famous Gospel manuscript written in Lindisfarne late in the seventh century (pl. 5). Fantastic animals intricately interlaced, knots, spirals and step-patterns – in short, the whole stock of barbarian ornament – have been poured over the page to decorate the sacred text. In this and many other Irish and Northumbrian manuscripts there are pages covered entirely with ornament: a thing unheard of in the south, where miniaturists used ornament only to mark the beginning or end of a chapter or to frame an illustration: a leaf bearing nothing but ornament would have appeared meaningless to them. In the north, however, a page did not need writing or an illustration pertaining to the text to justify its inclusion: a manuscript was as suitable an object for pure decoration as a knife or a brooch. Ornament represented everything that was rich, splendid and beautiful, and where the artist related it to holy scripture it was his own way of glorifying God.

These ornamental pages are extreme cases of barbarian taste trespassing on Christian ground. Definite attempts were made to introduce the figural subjects of southern book-illumination, but it is astonishing to see the complete independence with which the northern artists approached their models and the markedly abstract effect they achieved even when representing the human figure. An evangelist portrait in the Lindisfarne Gospels (fig. 17) has no scenic background: there is no indication of the space in which the evangelist sits, and no effort has been made to disguise the blankness of the page. The only piece of furniture, the stool, has been turned into a curious pattern of ornamental ribbons hardly solid enough to support the occupant. In fact, all the parts of the picture – the human figure and the bird no less than the stool – have been treated as one ornament. Nothing is more telling in this connection than the way the inscriptions have been arranged: they too are part of the pattern, counterbalancing the eagle above the evangelist's head and forming with all the other parts a display of perfect, if asymmetric, harmony. The empty ground has been used to set off this pattern, and the effect is that of openwork ornament on metal foil. Based as they were on models of an entirely different character, these evangelist portraits are the best witness to the northern artist's overriding taste for ornamental design. With his frankly abstract and unnaturalistic approach to his subject, he succeeded almost at first attempt in doing what artists in the south had aimed at for so many centuries, creating the true image of a saint, superhuman and wholly imperturbable.

The pre-Carolingian works of the north are, in fact, the perfect embodiment of the ideal of abstract art, the absolute antithesis of naturalistic

representation. Compared with them, Mediterranean art of the Early Christian period, whether Classical or anti-Classical, is naturalistic and descriptive. The closest comparisons in the Mediterranean region come from those eastern regions which also favoured a largely ornamental art, and, when contacts with the south were established in the seventh and eighth centuries, Coptic and Syrian works often had greater attraction for the northern craftsman than the more Classical art of Constantinople. There is an affinity between a Northumbrian page completely covered with a carpet-like pattern (pl. 5) and a Coptic tombstone (fig. 15), and in many northern works, especially of Irish and Merovingian art, there is moreover a demonstrable eastern influence. The early Christian civilisation of Ireland, England and France was largely monastic, like that of Egypt and Syria, and monks and hermits in the extreme north and west of Europe naturally maintained closer contacts with their brothers in the East than with the more cosmopolitan civilisation of Constantinople.

It is of great historical importance that the northern peoples, for whom purely abstract art was a natural form of aesthetic expression, now began to take a leading part in European development. Their influence on the subsequent evolution of Christian art did not at once become apparent, however, for the continuity of artistic production in the north was interrupted by the Carolingian renaissance. Barbarian art was abstract to a degree which nearly precluded its use by the Roman Church; it was inarticulate, and, being incapable of conveying a definite message, it was not suitable as an instrument of instruction or propaganda. The northern style was entirely inadequate for the illustration of historical matter, and this is undoubtedly one of the principal reasons for the much more complete adoption of Mediterranean models which Charlemagne initiated: its wide range of subject-matter and the graphic and lifelike manner in which this was presented made southern art immensely attractive to the great organiser of Germanic civilisation. We must be careful not to look upon Charlemagne's renaissance as though it were merely a matter of aesthetics, of replacing a harsh and heavy barbarian manner with a much softer and more elegant style. The main point is that by faithfully imitating Byzantine or Italian manuscript illustrations, paintings, mosaics and sculpture the northern artists became capable of depicting sacred stories, the subjects treated in the works of Classical and contemporary authors, the Emperor and other leading figures of the time, and to do so in such a way that these subjects really came to life. It was a discovery of naturalism, although, as so often in art history, the naturalism came not from direct

study of nature or drawing from life but through recourse to works of art of a preceding period.

It was not, indeed, one of Charlemagne's aims to make artists appreciate and reproduce the outside world for its own sake; in fact, he and his contemporaries condemned the use of art for reproducing things already obvious to the senses. They did, however, believe in its value for conjuring up figures and events of the past and making them live. Charlemagne had a very clear vision of the role such naturalistic art could play in his work of political and cultural reconstruction: if art could give physical form to things which could otherwise only be grasped conceptually, it could be turned into a powerful instrument of education. This is the real reason why the abstract ornamental art of the north was abandoned in favour of Mediterranean models.

An additional reason was that these models still bore the stamp of the Classical age and recalled the great Empire which Charlemagne had set out to revive. In itself, this would have given rise to little more than a dry and sterile Classicism, however, which would have died out with the disappearance of the political power which had brought it into being. As it was, northern art was established on an entirely new footing which was to determine its character for ever after, and, far from confining itself to mere formal imitation of Roman or Byzantine work, it was soon to produce masterpieces like the Utrecht Psalter and the Lothar crystal (fig. 21), in which the figures – although clearly based on Mediterranean models – have been rendered with such a lively sense of movement and drama, with vivid gesture and realistic expression, that the artists must be credited with having surpassed their Mediterranean forerunners at their own craft. In such cases the Classical forms are scarcely more than the raw material, beaten into a new shape by artists with a fresh and unblunted power of observation. The Carolingians did not aim at mere imitation of Classical imagery: their artists were imbued with a desire for lifelike and graphic representation, and, turning to this task with a fresh and eager eye, they often achieved a degree of perfection which few of their more or less decadent models can have possessed.

Art thus became a means of instruction and enlightenment, part of the programme of education through which Charlemagne intended to raise his people from barbarian obscurity to European leadership. In the churches and monasteries, which were the centres of all his educational work, he possessed an instrument for the systematic organisation of his artistic revival; the clearness of purpose and its methodical and comprehen-

sive implementation are not the least important features distinguishing the Carolingian renaissance from the north's previous approaches to Mediterranean art. The great monasteries, as well as the imperial palaces, had workshops attached to them. The most important centres were those near the heart of the Empire on the lower Rhine and in northern France – Trier, Aachen, Rheims, Metz and the monastery of St Martin at Tours – but great artistic activity was also displayed in comparatively remote places like Salzburg, the Bavarian monasteries and St Gall in Switzerland.

A look at a group of Carolingian works (figs 19–23, pls 6–8) shows the great difference between them and the barbarian work of the preceding period. There is a much wider range of subject-matter: New Testament iconography was no longer confined to solemn images of Christ and the evangelists, and scenes from Christ's childhood, miracles and Passion were depicted in elaborate narrative cycles, while Old Testament stories were also frequently illustrated. Equally striking is the difference in style. Figures are plastic in appearance, often caught in three-quarter view, and move about naturally and with great liveliness; their gestures are expressive and convincing and their garments softly modelled, with the folds rendered true to nature. We seem to be carried back to the art of the Cotton Genesis and the Projecta casket.

At the same time, however, it is obvious that by their comprehensive espousal of Mediterranean art Charlemagne and his followers took over the stylistic discrepancies inherent in it. The southern works which served as models must have differed greatly among themselves: out of the common Classical traditions strongly divergent styles had developed in the different Mediterranean regions during the Early Christian period. Charlemagne may have recruited artists from many of these regions, and with them their native styles. An even greater variety of influences came from the many objects of art procured from various sources to serve as models in Carolingian workshops. By copying from the same models again and again, local stylistic traditions were built up in individual Carolingian schools, and these styles continued to reflect the different southern sources from which they had been derived. In the styles of rival Carolingian schools the conflicts inherent in Late Antique and Early Christian art were thus perpetuated.

Among the various Mediterranean styles to influence Carolingian art was the lively impressionism of Hellenistic times which, as we have seen, had continued to flourish in Constantinople and elsewhere along the eastern shore. Some book-illuminations, painted at the time of Charlemagne himself and traditionally attributed to the 'Palace School', are

FIGURE 18

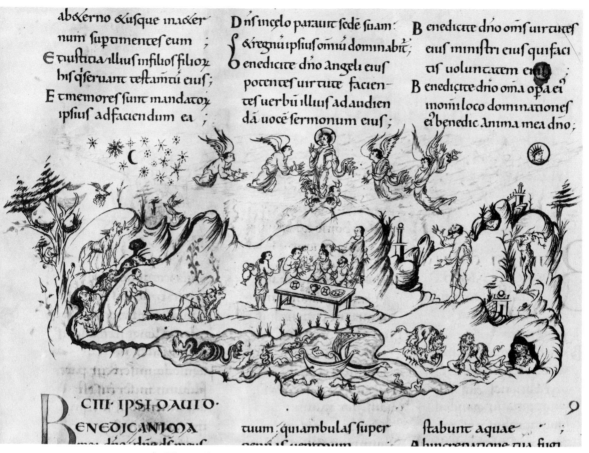

Illustration of Psalm 104, from the Harley Psalter.
Probably made at Canterbury, about 1000. Width 31·5 cm.

genuinely Byzantine: one of them is actually inscribed with a Greek name, and there can be little doubt that direct influence from Byzantium was responsible for their style. Under Charlemagne's immediate successors, in the second quarter of the ninth century, the miniaturists of Rheims followed the model of this school, and in their hands the sketchy impressionistic manner of the Greek prototypes found its most faithful reproduction, as can be seen in the illustrations of the Utrecht Psalter. At least an impression of this most famous of all Carolingian manuscripts may be gained from the Harley Psalter (fig. 18), which is a copy made in England in about the year 1000. In their turn the painters of Rheims handed on the tradition to a school of ivory-carvers who copied the miniatures of the Utrecht Psalter, imitating the style as closely as the different medium

53

FIGURE 19

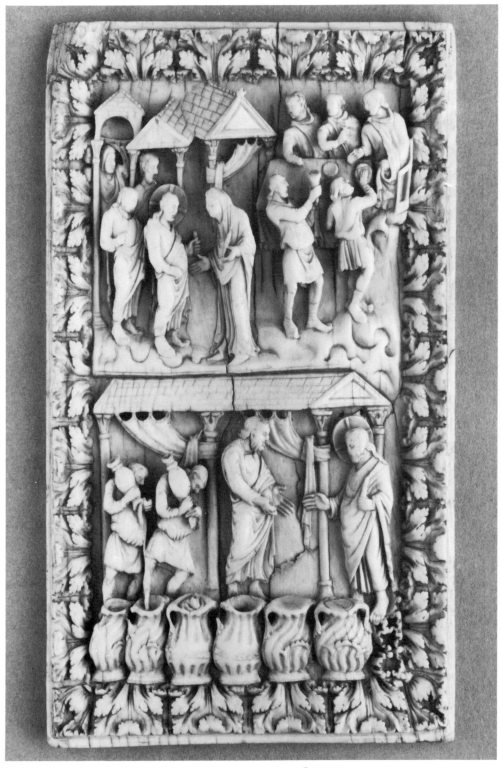

Ivory with the Miracle at Cana.
Liuthard Group, third quarter of ninth century. Height 14·5 cm.

would allow; the Miracle at Cana ivory (fig. 19) belongs to this school, known as the Liuthard Group. There is reason to believe that the Liuthard ivories were produced a generation after the Utrecht Psalter, and so, in the sequence represented by the Palace miniatures, the Rheims miniatures and the Liuthard ivories, we can trace the survival of the Hellenistic style of Byzantium through the three consecutive generations during which Carolingian art was at its best.

Side by side with the Palace School another group of artists, known as the Court School or Ada Group, had begun to evolve an entirely different style. Their manuscripts and ivories, thought to have been created under the immediate influence of Charlemagne's court at Aachen, were based on entirely different Mediterranean models from those used by the artists of the Palace School and their successors. Figures, especially in the earliest manuscripts, were drawn with heavy outlines; they are not by any means as lively as those of the Palace School, and instead of being surrounded by open landscape and atmospheric space they have been fitted into heavy architectural framework. The absence of impressionistic technique and of modelling in light and shade means that the figures are apt to be flat and somewhat rigid; their greater solemnity suggests that they are examples of official court art. The source of this style has often been thought to be the eastern hieratic style, found in Constantinople and other eastern centres side by side with the Hellenistic narrative manner, but the closest parallels to these stiff and solemn figures with their regular features, wide eyes and heavy outlines are in contemporary wall-paintings in Italy, where one also finds the background acting as a solid framework for the figure and holding it immovably in position. Italian artists had by that time brought to perfection the structured style they had favoured since the Late Antique period: they had consistently transformed Classical figural compositions by introducing such structural principles as symmetry and frontality, by excluding all suggestions of natural life and by subordinating everything to a strict system of horizontal and vertical lines. This style is clearly reflected in the earliest works of the Ada Group, which thus represents the abstract and geometric western Mediterranean element within Carolingian art, as opposed to the descriptive and narrative eastern Mediterranean style of the Palace, Rheims and Liuthard artists.

As the Ada Group developed, however, secondary influences began to modify its style. Figures became more lively and truer to nature, their bodies were given a more plastic character, the folds of their garments acquired a softer and more natural shape, and the backgrounds, although

still strictly structural and often architectural, became more spacious. It is to this period that the Harley Golden Gospels (pl. 6) and the Ada ivory (fig. 20) belong. They still show the linear style characteristic of the group, but a definite influence from more Classical models can also be seen. Compared with works of the Palace and Rheims schools the Ada evangelist still seems flat and constrained: he is surrounded by a strongly conventionalised architectural frame, and everything in the picture is drawn with a heavy outline. The elaborate distinctness of all the forms, a primary characteristic of the Ada style, is equally evident in the ivory panel, especially when compared with the Liuthard ivory (fig. 19). But in both the painting and the ivory carving the original stiffness of the Ada style has undergone a relaxation.

The niche in which the evangelist sits is fairly spacious. His pose is natural, and the rich folds of his garments are subtly modelled with soft, dark strokes and thin, flickering highlights. If we compare this page with a miniature from Byzantium, albeit a later one (pl. 9), it becomes apparent that the softening of forms is due to influence from that quarter. It was in Byzantine painting that the impressionistic modelling of figures and draperies, the drawing of architecture in perspective, and the technique of subtle light and shade had survived. The Carolingian painter absorbed these forms without, however, abandoning the essentially linear and structural character which the Ada Group favoured. Byzantine influence is noticeable in many of the later works of the group, both in its miniatures and in many of the large ivory book-covers it produced.

It was not only through Byzantine models that the artists of the Ada Group became familiar with a more Classical and natural way of rendering figures and scenery than the original style of the group had equipped them for. In their search for Classical models they had found that the Latin West also possessed such works, although this time not contemporary. They were attracted to the ivory carvings produced in Italy during the aristocratic revival of the Classical style in the late fourth and early fifth centuries, and with that scrupulous and almost pedantic accuracy characteristic of the Ada Group they began to copy those works of a distant past. Our Ada ivory (fig. 20) is typical of this kind of work: it is copied from a western Early Christian work which must have been close in style to the Passion panels (fig. 6). We find the same sturdy figures filling practically the whole panel from top to bottom, the round faces with their bulging eyes and protruding lips, and the fat rounded limbs discernible even through the folds of a garment.

FIGURE 20

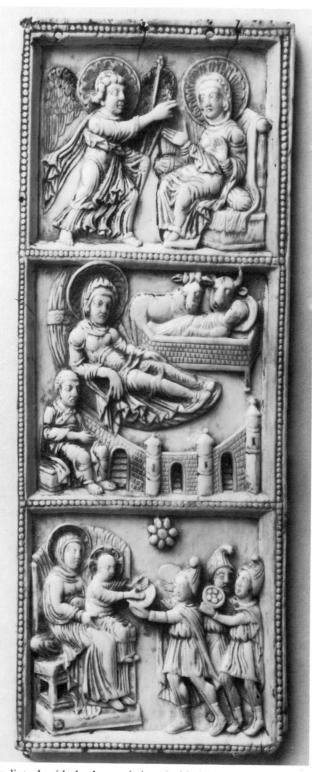

Leaf of an ivory diptych with the Annunciation, the Nativity and the Adoration of the Magi.
Ada Group, probably carved at Aachen, early ninth century. Height 16·5 cm.

The Ada Group produced a great number of works testifying to this antiquarian spirit, but the same spirit affected other schools, particularly the manuscript illuminators of Tours. Old Testament scenes in a large Bible written at Tours in about 840 (pl. 7) have figures, architecture, landscape, costumes and even colours so true to Late Antique art that the miniature can be confidently identified as based on a Roman painting of the fifth century. Of all our Carolingian works this is perhaps the one which most faithfully reproduces a work from an earlier age. It reveals the northern artist, only recently initiated into the secrets of descriptive images, sitting at the feet of the Classical masters. If we try to fit together the heads, bodies and feet of the figures in the lower part of the page, however, we quickly realise that this is not the work of an artist to whom the sympathetic representation of a historical event came naturally.

These few examples show the great variety of influences which helped to shape Carolingian art. Early Christian no less than contemporary Italian and Byzantine works contributed to its making. Yet as long as we confine ourselves to identifying its outside sources we do not do it full justice; equally important, although not always so easily discernible, is the contribution made by the northern artists themselves. Many painters and sculptors soon tired of slavish copying and began, sometimes perhaps quite unintentionally, interpreting their models in their own way. In this, too, however, different schools displayed different tastes.

Attention has already been drawn to the extreme liveliness the artists of the Rheims School and Liuthard Group imparted to their figures. In this respect they surpassed whatever southern models they may have had: no Byzantine miniature comparable in style to the illustrations in the Utrecht Psalter possesses quite the same expressiveness in movement or gesture, and the Liuthard ivories, in which this lively and versatile style was translated into a new medium, have an even stronger claim to originality. The closest parallels in the Mediterranean world to those delicate and agile little figures, with their quick movements and emphatic gestures, come from Asia Minor (fig. 27; see above, page 39), and it may well be that influences from that region contributed to the Rheims style. A work like the Utrecht Psalter or our Liuthard plaque is not all second-hand, however: although the scenery, the figures and the costumes conform to convention, the figures have had new soul, new life and new vitality breathed into them. For the artist the story had a degree of reality which made copying impracticable. He re-enacted the Bible stories in his own mind, and before him arose a fresh and dramatic vision of figures and

scenes; movement and gesture were barely adequate to express the emotional content he discovered. Suddenly enabled to use art as a means of portraying particular subjects, the artist was seized with an elemental desire to make it speak and give visual form to spiritual and emotional themes.

The supreme example of the rejuvenation of southern narrative style in Carolingian art is the crystal of Lothar (fig. 21). It is not known where this masterpiece was made, but the artist must have been at least acquainted with the work of the Rheims School, especially with the Utrecht Psalter, and the lively little figures enacting with a wealth of vigorous gesture the story of Susanna and the Elders have a vivacity all the more impressive because of the contrasting icy and intractable rock-crystal into which they have been carved. In a work like this we see the birth of a beauty exclusive to Medieval art, with its bold disregard for Classical harmony, correctness and restraint and its passionate interest in moral and transcendental subjects.

In these examples the special contribution made by northern artists came from their readiness to accept the aims of an illustrative and expressive art. Other schools, however, show the survival of the interest in pure ornament which had dominated pre-Carolingian art in the north. Indeed, a school of book-illumination in north-eastern France, known as the Franco-Saxon School, confined itself almost exclusively to imitating the work of eighth-century Irish and Northumbrian illuminators, with their marriage of Celtic and Anglo-Saxon art known as the Insular style. Manuscripts of the Franco-Saxon School (fig. 22), which had outposts in what is now Belgium and northern Germany, have the rich decorative framework of Insular illumination, with its characteristic corner-pieces, and the same huge initials of interlace and animal ornament completely dominating the page. The only Carolingian influence found in Franco-Saxon miniatures is the occasional acanthus border or the small figure of an evangelist inserted in the framework.

The Franco-Saxon School was of great importance in the dissemination of Insular ornament in Carolingian and post-Carolingian art, but in a subtler way the ornamental spirit pervaded other Carolingian schools. The artists of the Ada Group, for instance, took special delight in orna-mental elaboration: the draperies on our ivory (fig. 20) were certainly copied from Late Antique models, but these can scarcely have shown such a rich display of folds as that on Gabriel's garments in the Annunciation scene, where the ruffled hems have almost acquired the character of pure ornament, independent of the overall composition. The interest in rich

FIGURE 21

The Lothar Crystal, carved with the story of Susanna.
Carolingian, between 843 and 869. Diam. 11·5 cm.

FIGURE 22

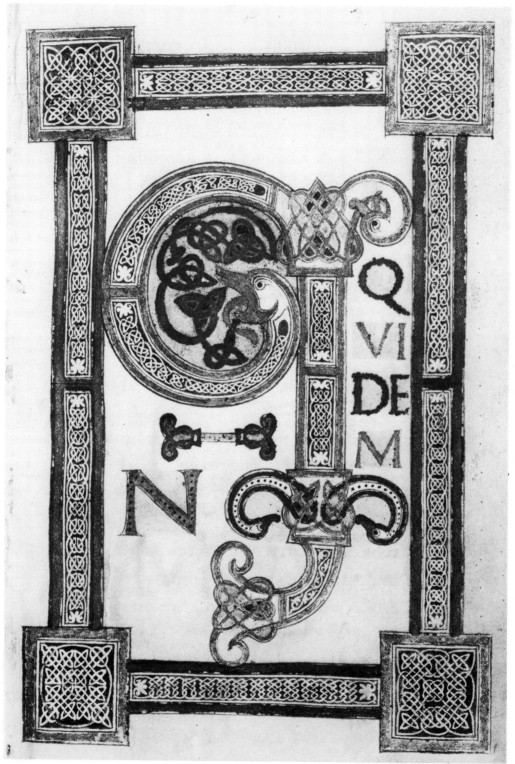

Opening page of St Luke's Gospel, from a Franco-Saxon manuscript.
Probably made in north-eastern France or Belgium, ninth century. Height of panel 22·5 cm.

ornamental design is even more pronounced in the Ada manuscripts: the artist who painted the figure of the evangelist in the Harley Golden Gospels (pl. 6) was clearly more interested in the zigzags and triangles of the draperies and their undulating hems than in the structure of the body underneath, and the elaborate architectural background, much richer than in southern manuscripts, enhances the ornamental effect of the page. It is not therefore surprising to find that several of the Ada manuscripts have pages almost entirely made up of ornamental motifs (pl. 8), including the interlace and fantastic animals of Insular art. Although many Classical details such as foliate capitals, acanthus friezes and other leaf ornament have been added, these are in essence decorative pages comparable to those in Insular manuscripts. The small scene inside the letter 'Q' in our example is of secondary importance.

It is significant that the repertory of abstract ornament, particularly the rich initials and other decorative features of barbarian manuscript illumination, was taken over by the Carolingian artist and amalgamated with Classical motifs. The belief in ornament for ornament's sake, so conspicuous in the pre-Carolingian art of the north, was thus perpetuated even after the Mediterranean principles of descriptive art had been comprehensively adopted. The artist who delighted in pure form and followed nothing but his own imagination did not disappear with the Carolingian renaissance. Mediterranean foliage ornament and even figures were added to the fantastic animal and knot patterns, but the spirit remained unaltered, and from the Carolingian schools the tradition was to be passed on to the mature art of the Middle Ages.

The Carolingian renaissance, therefore, did not involve total submission to the principles of Mediterranean art. In two different and even contradictory ways the north made its contribution to the art of the period: first, the search for naturalism led to an expressiveness unknown even in the best Mediterranean models, and, secondly, the tradition of abstract art was preserved. The two conflicting tendencies constituted a dilemma, which the Carolingians did not attempt to resolve: the Ada evangelist (pl. 6) and the Lothar crystal (fig. 21) are both Carolingian works.

The conflict was not entirely new but perpetuated, in a fresh form, the struggle we have already traced in the Mediterranean world. It is hardly a coincidence that the artists who excelled in expressiveness were those whose style shows Byzantine influence – for instance, the painters of the Rheims School – nor can it be chance that ornament played such a modest role in this school and was confined to the imitation of Classical motifs.

The abstract and linear style of the western models used by the Ada Group, however, lent itself to an ornamental interpretation, and purely ornamental motifs were easily added to figures already heavily stylised and geometric in design. The conflicting northern contributions were therefore associated with different Mediterranean models or, in other words, were merely interpretations of the conflicting Mediterranean styles. The old contrast between naturalistic Greek and abstract Latin art – between an art aiming at the sympathetic representation of the outside world and one based on purely conceptual design – presented itself anew as a contrast between the exuberant expression of human emotion and purely impersonal ornamental display.

From the point of view of Greek art both tendencies are, of course, anti-Classical, showing how much the distance from truly Classical art had increased since the northern peoples had taken the lead. The leaning towards expressive and communicative art involved a typically Medieval emphasis on meaning and emotional content at the expense of material form, while the ornamental spirit tended to exclude representation altogether. Within the Medieval world, however, 'expressionism' always ensured a certain degree of naturalism and a frequent return to Classical models with their rich stock of figure-types and other formulae convenient for the communication of a particular message, whereas the ornamental tendency was always uncompromisingly abstract.

The contrast between the two currents is, however, not always so clearly demonstrable as in the comparison between the Lothar crystal and the Ada evangelist. Particularly in the latter phases of Carolingian art, in the second half of the ninth century, the styles of different schools tended to become confused, artists often copying from the work of their Carolingian predecessors instead of going back to Mediterranean sources. Anxious to produce increasingly splendid and lavish effects, painters did not hesitate to copy a figure composition from Rheims or Tours and surround it with an ornamental frame in the manner of the Ada Group or Franco-Saxon School; a group of manuscripts, usually attributed to Saint-Denis, is particularly rich in such hybrid and eclectic features. The general tendency was towards ornamental rather than expressionistic effects, however, the vitality of the Utrecht Psalter and the Lothar crystal having disappeared. This late phase can be illustrated by ivories from the school of Metz (fig. 23). Although the models from which such works were derived must have been at least related to the Liuthard Group, nothing of the vivacity of the earlier works remains. The carving is much flatter, and gone are

FIGURE 23

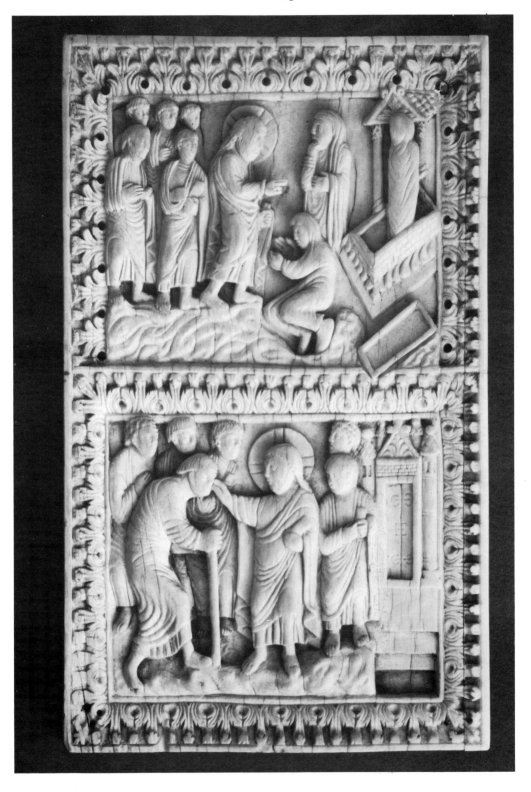

Ivory diptych with scenes from the life of Christ.

FIGURE 23

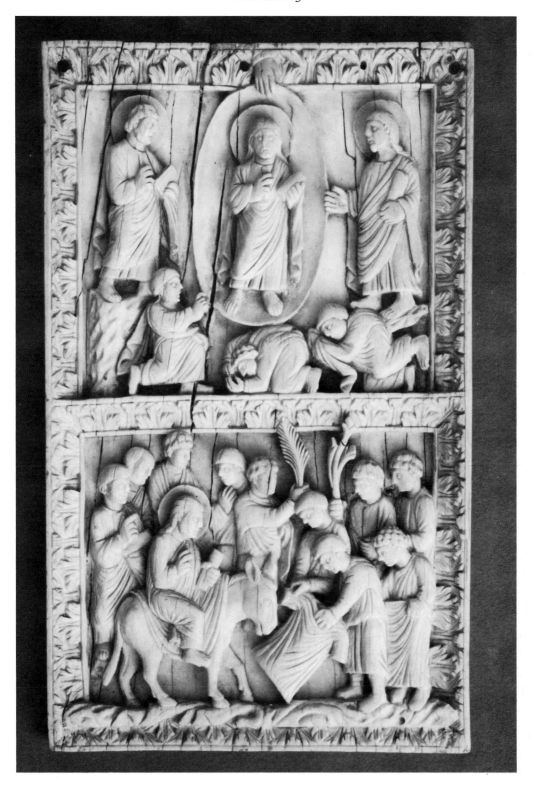

School of Metz, tenth century. Height 16·5 cm.

the deep shadows and bright highlights which throw the movements and gestures of a Liuthard ivory into bold relief. Outlines are much more defined, and figures have lost their agility; they are plumper and more stolid. Faces no longer reflect emotions but tend to be of uniform schematic design; details like eyes and mouths are no longer indicated in the sketchy technique of the Liuthard ivories, and a particularly characteristic feature is the stereotyped manner of representing the hair, which covers the head like a cap and is sharply set off from the face by a clean cut. The figures seem to have contracted into blocks; they are harder and colder, and although they still gesticulate expressively there is no real communication between them.

Despite these symptoms of degeneracy, the Metz ivories are still typical examples of Carolingian art and illustrate its survival into the tenth century. In the early years of that century the Frankish Empire collapsed, but the innumerable works of art created under the patronage of Charlemagne and his successors continued to be used as models in all the countries to which Carolingian influence had spread.

III

THE TENTH
AND ELEVENTH CENTURIES

While Carolingian art assumed the leading role in Europe, Byzantium, although no longer the main force in the evolution of Christian art, continued to be a powerful factor in the background. A wide schism had developed between East and West: in the course of the Iconoclastic controversy the Latin Church had separated itself completely from the Greek, and all but the very south of Italy had gained political independence from the Eastern Empire. The Byzantine sphere of interest was becoming more and more confined to the East and to the Balkan and Slav countries. In the artistic field, Byzantium remained faithful to its old traditions and had no share in the new departure made by the Germanic peoples in northern Europe; it is precisely this conservative attitude which ensures its importance in the general evolution.

Throughout the Early Christian centuries, Byzantium had remained the guardian of Classical art. Even the crisis of Iconoclasm had not meant a complete break with tradition: although few works of the period have survived, we know that painting and sculpture, as well as the minor arts, were practised to some extent even during the eighth and early ninth centuries. There was no objection to the representation of secular subjects or to purely decorative art, and even the prohibition of religious images was not enforced with equal rigour in all parts of the Byzantine Empire. For indirect evidence of Byzantine style in the late eighth and early ninth centuries we have the Carolingian works inspired by Greek artists – the works of the Palace and Rheims schools and the later products of the Ada Group, for instance. These show that even at that period Byzantine craftsmen had mastered the techniques of naturalistic figure drawing and impressionistic representation.

Direct evidence of artistic activity in Byzantium during the Iconoclastic period is meagre, however. It was not until the end of the ninth century, when the establishment of the Macedonian dynasty brought a return of prosperity, an increase in political power and a revival of all kinds of

FIGURE 24

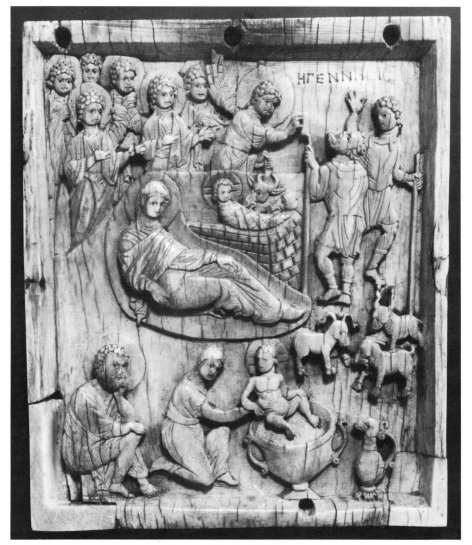

Ivory with the Nativity.
Byzantine, tenth century. Height 11·5 cm.

cultural activity, that works of art became numerous again. Some of the Macedonian emperors, besides being great patrons of learning and literature, restored buildings and decorated them with splendid mosaics; the minor arts, such as manuscript illumination, enamelling and ivory carving, were also revived on a large scale. The tenth century was a period of great aesthetic achievement, comparable to the time of Justinian and often called the second golden age of Byzantine art.

In works typical of the period (figs 24–7, pl. 9) a strong Classical element is apparent. Figures on a Nativity ivory (fig. 24) provide a good example: Mary reclining comfortably, the midwife in a natural and perfectly balanced kneeling pose bathing the infant Christ, and the figure of Christ himself, doll-like and clumsy, it is true, but carved with a knowledge of the nude which only an unbroken tradition of Classical craftsmanship could have supplied. Such Byzantine carvings show neither the minute elaboration of detail which reveals the ivories of the Ada Group as the work of imitators only recently initiated into the art of naturalistic figure drawing nor the emphasis on expression and dramatic effect which betrays the fundamentally anti-Classical character of the carvers of the Liuthard ivories. Byzantine figures always show greater poise and ease in their poses. A comparison of the seated Joseph in the Nativity scene with his counterpart on the Ada ivory (fig. 20) demonstrates that in Byzantium Classical art was a living tradition and not a deliberate innovation.

The Macedonian period is often called a renaissance, but the term is misleading in so far as it suggests a complete renewal, and a rediscovery of Classical art. The activities of the age did, however, constitute a revival and a broadening: as a result of a renewed interest in Classical science and literature, many Antique figure-subjects were re-introduced, and we find ivory caskets decorated with scenes from Classical mythology and manuscripts where the text of a Classical poem or scientific treatise is accompanied by appropriate illustrations. The stylistic execution and ornamental motifs also frequently reflect a closer study of Classical prototypes, and the works of the period are altogether on a higher level of artistic refinement than those of the preceding ages.

At the same time eastern influences are still apparent. Byzantine art had always preserved a hieratic style side by side with the Classical descriptive one. The age of Justinian had produced not only paintings and sculpture of a lively Classical character but also the long rows of figures standing in monotonous solemnity against a gold background. It is therefore not surprising to find, side by side with such narrative representations as our Nativity scene, a group of hieratic ivories – mostly little altars and triptychs – with figures ranged like columns in complete isolation. The figures on the Borradaile triptych (fig. 25) are displayed against a wide, empty background. They are tall and slender and betray no emotion; all signs of individuality have been suppressed, and faces and poses have become stereotyped. The Crucifixion is no longer shown as a story: the narrative picture has become a devotional icon. In works of this kind there

FIGURE 25

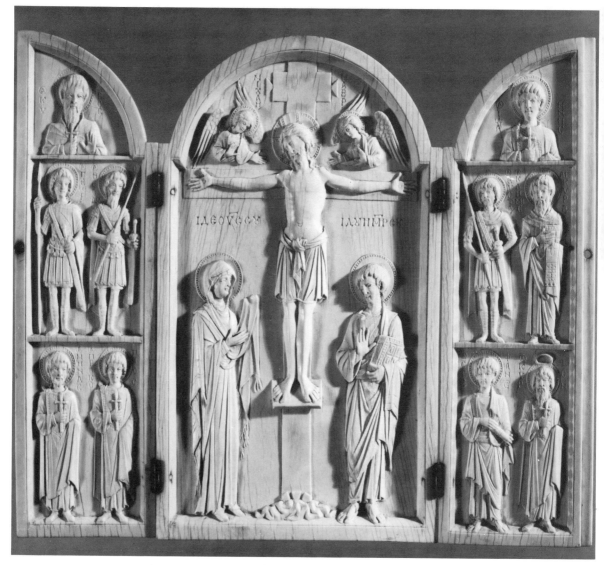

The Borradaile Triptych.
Probably carved in Constantinople, mid-tenth century. Height 27·5 cm.

is an element of dryness and sterility, which is often held to be a failing of Byzantine art and is conspicuous in its later derivations in Russia and other Slav countries. An ornamental marble slab from Constantinople (fig. 26) belongs in this category, although here the characteristics become more understandable with the realisation that the intention behind the relief is symbolic rather than naturalistic, the hares and the serpents being

FIGURE 26

Marble panel with allegorical representations of animals, from Constantinople.
Tenth or eleventh century. Length 241 cm.

allegorical representations of Man and the Devil respectively, overpowered by an eagle symbolising the triumphant Christ.

This dualism of Hellenistic and Asiatic traditions is fundamental to Byzantine art, but, as our examples clearly show, the two currents which had co-existed for so long had come to influence one another. The figures on the ivory triptych are for all their solemnity still the work of an artist who took account of the organic structure of the bodies and the soft and natural modelling of the folds and draperies; the taste for subtle and delicate detail is characteristic of all the best works of the Macedonian period. The rigidity of the figures is tinged with naturalism: their poses, although firm and austere, are still easy and relaxed, and the expression on the faces, although stereotyped and impersonal, is at the same time gentle and human. The balance between solemn representation and individual life reveals an affinity with Classical works which is in the true spirit of Byzantine art.

Equally, the narrative and descriptive works had acquired something of the monumental character of the hieratic style. The Nativity relief (fig. 24), instead of providing a naturalistic view of the cave with Mary and Joseph, Christ, the midwife and the shepherds, has the figures arranged in a formal composition with the Virgin at its centre. She is no longer really part of a narrative but an object of adoration, with a chorus of secondary figures surrounding her and the Child in the manger; a crowd of exulting

angels adds to the solemnity of the scene. There is a strong tendency towards the static, monumental and ceremonial, which may also be found in an evangelist portrait in a tenth-century Byzantine Gospel book (pl. 9). This contains all the traditional elements of such portraits – seat, writing-desk and implements, and architectural setting – but the architecture has dwindled to a frail arch much less prominent than the expanse of empty gold ground against which the evangelist's head is set in solemn isolation. Wide stretches of empty background are typical of Byzantine art of the period; a relief as crowded and ornate as the archangel ivory (fig. 8) would be inconceivable in the tenth and eleventh centuries. The quest for the simple and the monumental is characteristic of later Byzantine works, whether hieratic or narrative; in this respect they set themselves apart from all the styles evolved in the Carolingian schools, whose works seem restless and overloaded by comparison, and they bear witness to a new concept of the picture and its function. Figures solemnly displayed on a spacious and neatly framed panel are monumental rather than pictorial; they are no mere accompaniment to a text but are there to edify and to be venerated. The renewal of the cult of images after the Iconoclastic period may have been at least partly responsible for this change, the eventual outcome of which was the Russian icon.

The new dignity and solemnity were essentially the concern of the court. Monasteries, particularly in the remoter parts of Asia Minor but also in the capital, continued to cultivate their taste for lively and naturalistic representation. In fact this style, which we have seen to be typical of monastic art in Asia Minor ever since the early Byzantine period, now flourished more strongly than ever. On a page from an eleventh-century psalter (fig. 27) the Israelites are seen gathering the manna and roasting the quail which God has sent them. The minute lively scenes, scattered loosely and randomly over the margin of the page, exemplify a style which had been practised in the region for centuries.

In the West, the style – or, rather, styles – inherited from the Carolingian schools were superseded in the second half of the tenth century by fresh, spontaneous movements in several countries. The Carolingian Empire had fallen, and from its ruins individual nations had begun to emerge: France and Germany had started separate lives under different ruling houses, and the other European countries, faced with their own particular problems and struggles, gradually assumed distinctive national features.

The political separatism of the period had its counterpart in art history.

FIGURE 27

Illustration of Psalm 78, from a Byzantine psalter.
Eleventh century. Height 11·5 cm.

Much more markedly than in Carolingian times the new movements of the
second half of the tenth century were associated with particular countries,
where artists began to create their own styles. How very different the
results were can be seen by looking at tenth and eleventh-century works
from England, Germany, Italy and Spain (figs 18, 28–30, pls 10–12). It is
a curious fact that these separate styles, although apparently unconnected,

73

emerged more or less simultaneously. The collapse of the Carolingian Empire had left vast areas of Europe in chaos, to which various barbarian invaders contributed, particularly the Huns in central Europe and the Danes in England. In contrast, the late tenth century was in many respects a period of reorganisation. Most important, perhaps, from the art historian's point of view, monastic reform found vigorous champions in the monks of Cluny and spread to many European countries; in England, France and Italy the revival of the arts was certainly due to spontaneous efforts in reformed monasteries, and this accounts both for the contemporaneity of the movements and for the individuality of the styles in the different countries. In Germany an additional stimulus was provided by the revival of imperial power under the Saxon dynasty; since many of the outstanding works of the period owe their existence to the patronage of the emperors, the first three of whom bore the name of Otto, this whole phase of German art is usually known as Ottonian.

At this time English art entered one of the most significant periods in its history, one in which the creative genius of the island blossomed as it had done only once before, in the days of the early Church. Carolingian art had not found a ready response in Anglo-Saxon England, and the arrival of the Danes had meant that for nearly a century English art had consisted of a mixture of debased Carolingian motifs and Scandinavian animal ornament, found on the West Saxon crosses of the period, for instance. It is difficult to say why the flame was so suddenly kindled in the late tenth century; while St Dunstan's monastic reforms had prepared the ground, they do not account for the artistic invention which, within little more than a decade, evolved a new and original style so mature and elaborate that it would seem to have been the result of a long and gradual development.

The foremost place in the art of the period belongs to the Winchester School, which produced a series of splendid illuminated manuscripts during the last decades of the tenth century and the earlier part of the eleventh. The artists clearly used Carolingian works as models: some of the figural compositions of the Winchester School were taken from ivories of the Metz group, and the restless folds of the draperies with their nervous outlines remind us of certain figures of the Ada Group (pl. 6). The sprigs of acanthus playing freely about the frame, a hallmark of the Winchester style, can be found in a group of Carolingian manuscripts associated with Metz. From the outset, however, only those motifs which

fitted a preconceived notion of a new artistic effect were chosen. There is an entirely new relationship between figures and ornament never found in Carolingian works. The frames in early Winchester manuscripts are unusually broad and heavy and are much more than merely a border for a figural scene: they form an essential part of the composition. Often the figures actually stand on the bars of the frame or appear to grow out of the foliate ornament. In other cases, as in the portrait of St Luke in the Grimbald Gospels (pl. 10), the connection between figures and frame is subtler; the rich baroque sprigs of foliage exert a kind of magnetic attraction which holds the figure in indeterminate space. In one way or another Winchester figures and ornament are always closely linked. They seem to be made of the same material: they have the same ruffled surface, with little flickering highlights playing over it, and outlines so unsteady that flames seem to be shooting up incessantly on all sides. The St Luke page is not merely a portrait: it is at the same time a large and sumptuous openwork ornament on a blank ground.

In other words, the artist had returned to the principles which had guided the painters of Irish and Northumbrian manuscripts in the seventh and eighth centuries: in the Lindisfarne Gospels we found figures floating in space and displayed like an openwork ornament (fig. 17). By entirely different means a similar result was achieved in the tenth-century manuscripts. It may be contended that a deep-seated national instinct made the Winchester artists treat their Carolingian models in a spirit so closely akin to that found in early Northumbrian miniatures, but there were concrete links between the two periods. For one thing, manuscripts of the earlier period were available: an eleventh-century Gospel book in Copenhagen contains an evangelist portrait based on one of the illustrations in the Lindisfarne Gospels. More important than this significant but isolated instance of antiquarianism is the living tradition of Insular art provided by the Franco-Saxon School (page 59): we find there the ornamental pages of the Irish and Northumbrian manuscripts perpetuated in the ninth and tenth centuries. Although the details of the Winchester miniatures are all new and different, the concept is still the same as that underlying a Franco-Saxon page (fig. 22). Both have the same framework, in one case filled with abstract knot patterns, in the other with acanthus and figure work. These details are hardly more than accessories; the skeleton of the page is still the old Insular design of a heavy frame with large ornamental corner-pieces, which found its way to the Continent in the ninth century and had now returned. Franco-Saxon manuscripts in which the old

interlace and animal ornament has been replaced by Carolingian acanthus and human figures foreshadow the Winchester miniatures even more closely. Many other details of Winchester ornament were derived from the Franco-Saxon School: some of the initials are practically identical, and the panels of acanthus making up the borders of, for instance, the Grimbald miniatures also have their closest parallels in Franco-Saxon manuscripts.

The ornamental character of the Winchester manuscripts is thus accounted for by an uninterrupted tradition of the old Insular style, but we do scant justice to the miniatures if we regard them merely as ornament. There is a great deal of movement and animation in them: figures gesticulate vigorously, their heads turn upwards or to the side and their garments flutter in all directions. It is a liveliness emanating not from the figures themselves but from the painter's own exuberant imagination; it does not stop short at the figures but pervades even the foliate ornament. The whole page is in a state of vigorous excitement, as though a storm were raging over it.

The source of the nervous expressiveness in the Winchester miniatures has often been identified as the illustrations of the Utrecht Psalter, but although this manuscript is known to have been in England in the late tenth century there are no signs of a direct connection between it and early manuscripts of the Winchester School. It would be safer to say that the artists of Rheims and Winchester were informed by the same desire for intense animation. This affinity, however, made the English artists extremely susceptible to the influence of a work like the Utrecht Psalter, and it is therefore no surprise to find that this manuscript subsequently became very important to English illumination. Many signs of its influence are seen in the line drawings illustrating a particular group of manuscripts made in various English monasteries, including Winchester, from the late tenth century onwards. The Harley Psalter (fig. 18), made at St Augustine's, Canterbury, about the year 1000, has already been mentioned as a direct copy of the Utrecht Psalter. It provides the main evidence for the influence exerted by the Rheims style on English draughtsmen, and at the same time shows how thoroughly its nervous and excited manner suited their own intentions. Had it not contained what they themselves were looking for, they would never have achieved such a faithful reproduction of a seemingly inimitable style.

Most English drawings of the period are strongly influenced by the Utrecht Psalter, although the faithfulness with which the style of the original has been followed varies considerably. A miniature from another

FIGURE 28

St Pachomius receiving the Easter Tables, from a Late Anglo-Saxon manuscript. *Canterbury, mid-eleventh century. Width of miniature 12 cm.*

Canterbury manuscript (fig. 28) has many of the features of the Carolingian model: bent, round-shouldered figures with heads jutting forward, expressive angular eyebrows and vigorous gestures, and the same pen technique, with sudden changes from delicate to heavy strokes and the distinctive whorls and sharp zigzag scribbles representing the ground. All these features have been slightly exaggerated in the English copy, however, and a touch of the grotesque has crept in. Only in the later stages of the

Winchester School were painted full-page miniatures directly influenced by the style of the Utrecht Psalter. Figures became less stolid, with sketchier outlines and lighter body-colour; they also began to acquire the jutting heads of the line drawings. These features, however, merely accentuate the expressiveness which had been characteristic of the Winchester School from the very beginning.

This expressionistic tendency is as much a fundamental characteristic of English tenth and eleventh-century art as is the marked bias towards ornament. With all the figures and decorative motifs of his Carolingian forerunners at his disposal, the English artist pursued two aims, and with a vigorous independence which the Carolingians would have found impossible: it was perhaps his greatest achievement that he succeeded in combining the two tendencies which in Carolingian times had been distinct and associated with different schools. In a Winchester miniature it is impossible to separate the ornamental and the narrative elements: the features assembled by Carolingian artists had now been fused into a whole which was at one and the same time completely ornamental and completely full of life.

German Ottonian art, contemporary with this great period in England, affords both parallels and contrasts. Largely sponsored by kings and emperors, it was more pretentious and monumental and at the same time wider in scope. While in England comparatively modest churches were built, the German rulers embarked on great cathedrals like Speyer, Mainz and Bamberg, all of which were founded in the Ottonian period. Many monasteries, too, were imperial foundations or enjoyed the patronage of the emperors, and some of these became important centres of all kinds of artistic activity. In addition to imperial patronage, artists received great encouragement from some of the bishops, who were beginning to develop into powerful lords, building churches on their own account and commissioning all kinds of works of art, notably illuminated manuscripts and liturgical objects in bronze and precious metal. Egbert of Trier (977–993) and Bernward of Hildesheim (993–1022) were prominent among these ecclesiastical patrons of the arts. In Germany, therefore, there were many centres with distinctive styles of their own, practising a great variety of crafts ranging from monumental bronze sculpture and fresco painting to goldsmiths' work and enamelling.

As in England, art in Ottonian Germany was based on Carolingian models, but its style was quite different: while the English favoured

baroque exuberance, diffuse outlines and rich ornament, Ottonian art was rigid, stern and monumental. This style had been foreshadowed in the late Carolingian period and, unlike England, where an entirely new start was made in the late tenth century, Germany possessed a living tradition of Carolingian art, represented by such works as the Metz ivories (fig. 23), in which the Ottonian style had already begun to take shape. We notice a preference for heavy block-like figures, isolated from each other, and for regular, simplified composition; the continuation of these features in the Ottonian period is well illustrated by a work like the Widow of Nain ivory (fig. 29), which with a large number of similar plaques in various European and American museums may once have decorated an altar. Made in about 970, it is clearly related to the Metz ivories, but all their characteristics have been intensified: the figures are stiff and massive, the draperies straight and simplified, the hands big and clumsy, the heads large and rounded, with staring eyes. Most significant of all is the openwork pattern which serves as a background, showing the extent to which abstract tendencies had reasserted themselves. It gives an air of unreality to the scene, but the figures are themselves so strongly stylised that no contrast between them and their setting is felt.

As in England, certain groups of miniature-painters of the Ottonian period went back to original Carolingian works, thus proclaiming in the domain of art the revival of imperial power which dominated the politics of the age. They did not, however, as the English did, select elements from different Carolingian models to combine in a new organism; instead they clung faithfully to a particular set of models, and it is significant that the works most favoured were those of the Ada Group, belonging to the German rather than the French part of the Carolingian Empire and associated with the court and imperial ceremony. The linear and rigid Ada style, with figures firmly enclosed in architectural settings, suited the Ottonians much better than the manner of the Utrecht Psalter. They increased the monumentality by eliminating some of the ornamental details in which the Ada manuscripts were particularly rich, they substituted simpler forms for elaborate architectural details, and by generally suppressing unimportant features which might detract from the great lines of the composition they produced a clear statement of a new and distinctive artistic concept.

The Ottonian preference for monumentality received further support from Byzantium, an influence easily explained by a dynastic marriage between Otto II and the Byzantine princess Theophanu in 972. Ottonian

FIGURE 29

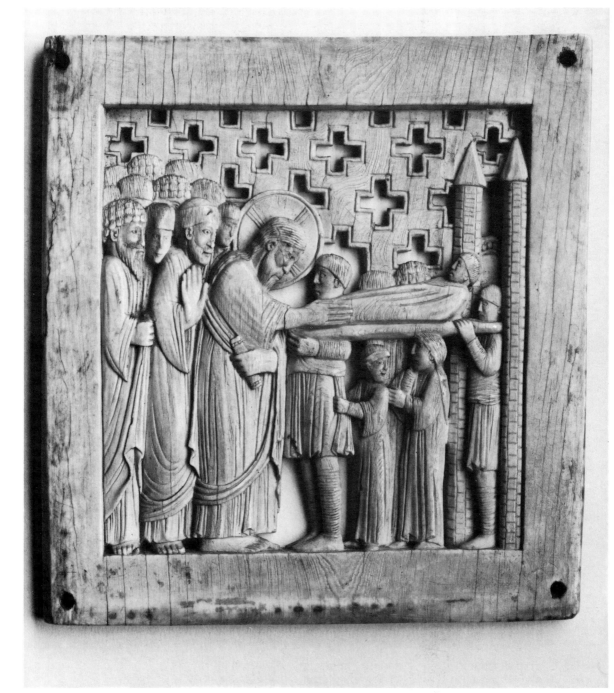

Ivory with the Raising of the Widow's Son.
Ottonian, about 970. Height 12·5 cm.

ivory carvings, for instance, often have stiff figures isolated against an expanse of empty background (page 69), and a whole surface crowded with narrative scenes as on Carolingian book-covers is seldom found. Single scenes filling a whole panel, wide stretches of neutral background and broad frames are all features equally characteristic of Ottonian and contemporary Byzantine art. Where the background is given more prominence through elaborate ornamentation as, for instance, on the Widow of Nain ivory the Byzantine influence is particularly striking; the gold plaque from Asia Minor (fig. 11) provides an early parallel.

An enhanced abstract and monumental quality is not the only characteristic of Ottonian art, however. In Germany no less than in England artists were impelled by an overwhelming desire to fill their pictures with emotional content. Nowhere is this feature more prominent than in the illuminated manuscripts traditionally attributed to the 'Reichenau' School, which are the masterpieces of Ottonian art. The earliest 'Reichenau' works, dating from the 960s, closely follow manuscripts of the Ada Group, but soon the artists became tired of illustrating their Gospels with portraits of the four evangelists, the habitual decoration of Ada manuscripts. In any case, the Ottonian period saw the appearance of Pericopes, books containing Gospel texts out of sequence and arranged according to the demands of the Church calendar and liturgy; in such books the portraits of authors had no place. A new type of illustration was called for, and it was supplied by elaborate pictorial cycles. In the Carolingian period New Testament scenes had been more or less confined to ivory book-covers, but as the narrative scenes on the covers were superseded by more solemn and formal figures, Bible scenes inside the book took on the liveliness and richness of detail which brush and colour alone could give. The artists devising these scenes found a model in the cycles of illustrations in Early Christian and Byzantine manuscripts; the stories of Christ's childhood, miracles and Passion were adapted from these models, from which the Ottonian miniatures also inherited a wealth of narrative detail and secondary figures to accompany the main events. The scene of Christ washing Peter's feet, for instance, invariably includes a disciple untying his sandals in anticipation of similar service from Jesus, and by the side of Lazarus' tomb we frequently find a man covering or holding his nose – a vivid evocation of the stench issuing from the corpse. Such figures, in which Mediterranean illumination was rich, gave Ottonian painters wide scope for their expressionistic tendencies. In certain Mediterranean manuscripts, especially those of Asia Minor, these dramatic qualities were already well

developed, and, when Ottonian figures seem to speak with their hands, when their eyes protrude from the socket with the pupil in the very corner, when figures are bent and twisted by emotion and when limbs undergo the most incredible contortions, it is in miniatures from Asia Minor that they have their closest parallels.

This vigorous excitement is no less an Ottonian characteristic than is the severely monumental aspect. The most significant achievement of Ottonian art is the way in which these two tendencies were combined, seen to perfection in the 'Reichenau' miniatures. The artists of Asia Minor, to whom the Ottonians were so indebted, had already begun to reduce scenery to the minimum and to place figures against plain backgrounds; this was in accord with the intentions of the Ottonian painters, but Ottonian figures stand out even more strikingly because of their clear, simple and inflexible outlines. Ottonian composition is often symmetrical, moreover, even the most animated figures forming a perfectly balanced group of geometrical simplicity. Far from reducing the emotional appeal of the figures, these stylistic conventions so typical of Ottonian art actually intensify it to an extraordinary degree. The simplicity and clarity of its outline make the twists and bends of a figure all the more expressive; the simplification of the background increases the effect of movement and gesture, for when figures are isolated in a vacuum, emotion expressed by the eyes and hands is the only link between them. Furthermore, the abstract regularity of a composition throws the liveliness of the individual figures into heightened contrast and at the same time frees them from the earthly sphere: they appear to be on a higher plane and to belong to a supernatural order with eternal validity.

It is the contrast between the impassioned content and the framework of monumental coldness and dignity which makes these paintings so effective. Between them the two tendencies have entirely transformed the inheritance from the Mediterranean and Carolingian models. Descriptive forms no longer have any intrinsic importance: bodies are, as it were, consumed by inner fire and at the same time bound by abstract laws. Held in suspension between these two magnets, matter is no longer affected by gravity. An artistic form had been found which was capable of expressing the purely spiritual and transcendental, a power Classical art had never possessed. Some of the 'Reichenau' miniatures could almost have been created in a state of religious ecstasy, as the record of a vision. Although so many of their elements were taken from earlier works, they have a directness and

fervour of expression which places them among the greatest triumphs of Medieval art.

Only a pale impression of the magnificence of these pictures can be gained from an Annunciation miniature (pl. 11) in a manuscript from Echternach, a monastery with artists closely related to the 'Reichenau' school. It shows hard, simplified figures with lively gestures, standing out against a neutral background. It is a perfectly balanced composition; the architecture of the city, which in the Early Christian prototype undoubtedly formed a naturalistic setting for the event, has been turned into a heavy frame encircling the figures and giving the narrative scene the character of a monumental group.

It would be difficult to conceive of a style more different from the English work of the period. While Winchester miniatures are exuberant and overflowing, the German ones have a firm and definite structure, and whereas in England outlines are diffused and nervous here they are steady and sharp. There is contrast also on the emotional level. While the expressive character of a Winchester page is a reflection of the artist's own temperament, here it is intimately bound up with the dramatic content of the scene; the artist has withdrawn, as it were, behind his subject, allowing the figures to play with great liveliness the roles assigned to them in the drama. The content of English miniatures, however lively, is much less specific: human shapes are apt to lose their individuality in the general turmoil of nervously drawn outlines. Furthermore, while German works, with their tense austerity and dramatic pathos, have no room for a rich display of ornament, the English painters allowed masses of decoration to play freely about the figures; they found an outlet for their excitement in ornament as well as in the human figure. Their excitement is, of course, religious, and Winchester art is a truly religious art. As illustrations of specific biblical texts, however, Winchester miniatures are almost as unsatisfactory as the pages of animal ornament painted by Insular artists three hundred years earlier, whereas German ones project a vision of a particular religious event.

For all their expressionistic character, however, the German works have a definite ornamental value, which they owe to the abstract structure of their composition and to the sharp contrast between figures and backgrounds. In fact, despite their differences, German and English styles share one fundamental point: in the German works no less than the English it is impossible to say where illustration ends and ornament begins. If the 'Reichenau' miniatures can be taken as ecstatic visions of

sacred scenes, they can also be seen as large ornamental patterns. The heavy structural style from the Ada Group is as much a factor as the emotional vigour from the Utrecht Psalter. In an entirely different manner, the Germans as well as the English succeeded in combining the two aims which both had inherited from Carolingian art.

In the art of the tenth and eleventh centuries, Germany and England played the leading roles. France did not develop its Carolingian traditions into a distinctive national style in the same sense. To some extent French artists continued to copy the works of the Carolingian period, but they also took over ready-made the contemporary styles of their neighbours. Thus we find strong English and Ottonian influence in northern France, while in the south an entirely different style can only be accounted for by the proximity of Spain. Even at that time the French showed a keen appreciation of subtle and delicate forms, but it was not until later that they began to display an artistic activity so vigorous, original and multi-faceted that they became the teachers of architects, painters and sculptors from all over Europe.

Italy and Spain, however, each had a clearly defined style of its own, markedly different from anything produced in northern Europe. The course of development in these two countries differed entirely from that in the north: from late Roman times there had been an uninterrupted tradition of Christian art in both Italy and Spain, and there had been little room for a Carolingian renaissance. In fact, only very slight influence from that movement had been felt south of the Alps and the Pyrenees. Except for a few instances, which have to be classified as direct offshoots of Carolingian art, we find neither the exuberant expressiveness of northern work nor the strong ornamental element, such as rich acanthus foliage or heavy architectural decoration. The miniatures – once again our most important and most characteristic surviving evidence – show a more sober and much simpler figure style. Based on Early Christian models, they have the somewhat primitive look which Rome and the western Mediterranean countries had evolved; the tendency towards flatness and linearity characteristic of these countries ever since the Early Christian period had strengthened in the intervening centuries, with the result that Italian and Spanish works appear much more archaic than contemporary northern art.

The miniature of Adam and Eve (fig. 30) from an illuminated manuscript in scroll form bearing the text of the Easter ceremonies dates from the eleventh century. These so-called Exultet rolls were a speciality of southern

FIGURE 30

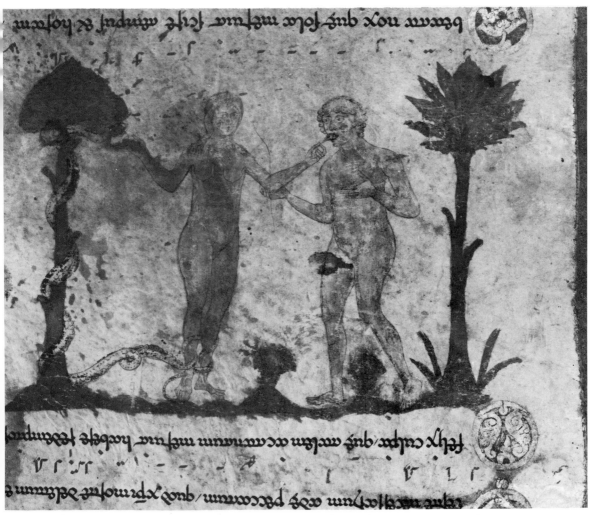

Adam and Eve, from an Exultet Roll.
From Montecassino, second half of eleventh century. Height of figures about 13 cm.

Italian artists, a typical product of the revival of monastic culture which all
Europe experienced from the late tenth century onwards. The centre of
that revival in Italy was the old Benedictine foundation of Montecassino,
and it is from there that our manuscript comes. Montecassino painting
clearly shows the persistence of the simple linear style which Italy had
evolved in Early Christian times and which, during the eighth and ninth
centuries, had survived chiefly among the fresco painters of Rome and
southern Italy. Figures drawn in outline and covered with a layer of flat

body-colour are typical of the style. There is no trace of the animation found in contemporary northern work: the Italian artist did not try to express all his religious passion with every stroke of the brush, but drew with a sober and steady hand. Figures, usually stiff and flat, are always clear and neatly outlined. Any scenery is also greatly simplified and usually consists only of isolated houses or trees, which are firmly fixed beside the figures and add to the solidity of the composition. The way in which Adam and Eve in our example are flanked by a tree on either side is typical of the sense of symmetry and structural composition which Italian artists had possessed ever since Late Antique times.

At the same time, the treatment of the nude betrays great familiarity with Classical drawing; it shows a softness and elegance which one would hardly have expected from an eleventh-century Italian artist. The truth is that our miniature no longer represents the pure Italian tradition: in the second half of the eleventh century, after having practised the stiff, angular manner they had inherited, artists at Montecassino turned their eyes towards Byzantium. The great abbot Desiderius (1058–1087), under whose aegis our manuscript was made, procured painters, sculptors and masons from the East, opening the gates once more to a steady stream of Byzantine influence, which – as so often in the history of Early Medieval art – brought an increase in naturalism, a freer and more organic style and a return to something like Classical beauty, all of which can be seen in these figures of Adam and Eve. And yet a comparison with genuine Byzantine work shows how much this miniature retains of the linear simplicity traditional to Italian art.

The strangest flower in the whole field of Early Medieval art is perhaps that which grew in Spain during these same centuries. Spain provides an instance of Christian art developing from but never renewing its contact with Classical traditions: it was not only untouched by the Carolingian renaissance but also remained outside the sphere of Byzantine influence. In Early Christian times, when the Roman Empire still held together, there were Spanish sarcophagi in the Roman style, and Spanish artists probably took part in the development of Christian book-illumination; subsequently, however, Spain was completely cut off from Classical sources. In their place came strongly anti-Classical influences from various regions. Coptic art probably found its way along the North African coast as early as the sixth century, and soon afterwards barbarian elements crossed the Pyrenees from Merovingian France. Most important of all, however, was the intimate contact with Islamic art brought about by the Moorish invasion early in

the eighth century: the southern part of the country fell entirely under Moslem domination. In the very north, in Catalonia and the Asturias, Christianity survived, but it absorbed many Islamic elements.

The results are most clearly seen in the so-called Beatus manuscripts (pl. 12), the most celebrated and most idiosyncratic products of Early Medieval Spain. They are illustrated editions of a commentary on the Apocalypse written in 786 by Abbot Beatus of Liébana; surviving manuscripts date from the tenth, eleventh and twelfth centuries. The painters did not invent their pictures: they probably had in front of them copies of the Apocalypse – the Book of Revelation – illuminated in the sixth or seventh century, by which time, however, Spanish artists had already drifted away from the general line of development in western art and had eliminated many Classical elements from their work. Even then Spanish art had acquired something of an exotic flavour, as can be seen from the miniatures in the Ashburnham Pentateuch in the Bibliothèque Nationale in Paris, which comes either from Spain or from the neighbouring North African coast; the models for the Beatus manuscripts were probably similar in style. The events of the intervening centuries, moreover, had increased the anti-Classical tendencies a hundredfold. Everything in the Beatus manuscripts is absolutely flat: there is no indication of depth in the composition and no modelling in the figures. These are as thin as paper; there are no folds in their garments, their movements are angular and rigid and their faces are indicated with a few straight lines.

In addition to these barbarian elements there are many features of Islamic origin to be seen in the Beatus miniatures. There is a profusion of Islamic ornament, horseshoe arches and Cufic lettering, and the fact that figural scenes are treated ornamentally and strewn with a variety of patterns as though they were carpets is also in accordance with Islamic taste. The colour scheme is completely unnaturalistic: only strong, bright hues were used, and the painters took delight in creating dazzling contrasts, particularly favouring the conjunction of red and yellow. This style, with its purely ornamental interpretation of the outside world, often reminds us of Irish art, but it is less likely that the many striking similarities were the result of direct Irish influence on Spain than that both countries had independently absorbed oriental elements. What is beyond doubt is that, like Irish art, the Beatus manuscripts represent a confluence of anti-Classical currents in the early Middle Ages. In this lies their significance and also their limitation. Their art, at the extreme of stylisation, lacks balance; it also lacked the opportunities for further development which

England, Germany, France and Italy derived from renewed contact with the Classical tradition.

The different styles evolved in the various European countries during the tenth and eleventh centuries can be explained partly by different external influences, which in their turn were largely the result of geographical and political circumstances, and partly by the particular aesthetic inclinations of the artists in the various lands. There was no longer an art representative of all Europe, as Carolingian art had been in the preceding period. Yet all the distinct styles had something in common: whether we take a miniature from Winchester or one from Ottonian Germany, whether we look at an Italian or a Spanish work, compared with Carolingian art they all show a clearer, simpler and more monumental conception. There is nothing of the *horror vacui*, that fear of emptiness, which made Carolingian artists fill every inch of a miniature or book-cover with figures or ornament: vast empty backgrounds are typical of tenth and eleventh-century styles everywhere. Artists still copied from Late Antique models, but no longer so timidly, conscientiously and minutely as the Carolingian miniaturists and ivory carvers had done. The later generation took a more independent view of their models, boldly conceiving new compositions of large-scale figures separated by empty space – monumental and austere compositions to fill a whole page, panel or wall.

Even Byzantine art, although based on different traditions and separated from the West by many barriers, aimed at similar effects during the centuries in question. There, too, as we have seen, there was a shift towards the hieratic and the monumental, although the formal results were quite different. To some extent the fundamental similarity of purpose may have come from direct links between the various western countries and Byzantium: Byzantine influence played an important role in Germany, and it may also have contributed to tenth-century style in England. Yet the monumental tendency expressed itself in so many ways in the different regions that it can hardly have been the result of direct influence alone.

In the tenth and eleventh centuries, however, there were undeniably certain general developments affecting all the countries, the most important being the increasing influence of the Church. Whether in opposition to secular power, as in the West, or by co-operation with the emperor, as in Byzantium, the Church attained a formidable position, which it was to hold throughout the Middle Ages. The Latin Church, particularly, after reaching a low ebb in late Carolingian times, underwent a process of

purification – largely a result of the activities of the reformed monasteries – and greatly increased its moral authority. Art was a means of bringing home to the faithful the force of Christian teaching, and that is perhaps the underlying reason for the monumental character it began to assume throughout the Christian world.

The need to express and propagate transcendental truth once more tipped the scales against the Classical tradition which had come so much into prominence in Carolingian art. The tenth and eleventh centuries, however, only marked the beginning of this counter-movement: its full effect was not to be felt until the development of Romanesque art in the twelfth century.

IV

ROMANESQUE ART

It is difficult to draw an exact line between the art we have just discussed and the Romanesque works which followed it. Many characteristics of twelfth-century style, such as heaviness, monumentality and rigidity, were the direct outcome of the development of tenth and eleventh-century art, which is in fact often known as Early Romanesque. The Widow of Nain ivory (fig. 29), carved in about 970, has a strong Romanesque flavour, and southern French and Spanish works, with their archaic character, also anticipated the new style.

If the development of figural art were alone to be taken into account, the continuity of the story might not need to be interrupted at this point. The word 'Romanesque', however, primarily describes an architectural style, and it is in the history of architecture that the second half of the eleventh century marks the most important turning point. It is true that earlier cathedrals foreshadowed Romanesque architecture even in certain stylistic features, but a great building programme was launched all over Europe at this time: in France, Germany, Italy, Spain, and in England, where the new departure was particularly evident, since it marked the break between the Anglo-Saxon and the Norman periods. It was not, however, a question simply of the number and size of the buildings: a new beginning was made also in the matter of style.

Romanesque architecture is commonly recognised by its round arches, but much more important is that, for the first time in Medieval architecture, an attempt was made to subordinate all the parts of a building to a system. Walls were articulated horizontally by tiers of arches, galleries and windows and vertically by shafts and pilasters, dividing up the length into bays. The problem which more than any other occupied the minds of the architects was that of linking opposite walls as part of the system; the pitched wooden roof in general use in the West was nothing more than a functional cover. The stone vaults with which architects now succeeded in spanning the whole church actively connected wall to opposite wall, and, as the

vaults were divided into bays complementing the articulation of the walls themselves, the whole church was given an impressive three-dimensional rhythm. The plain basilica which had long served the Western Church, its plan and structure determined by Classical precedents and by utility, had developed into a complex architectural organism comparable in structure to a musical composition. It had become a kind of fugue, a hymn to the glory of God.

This type of building, with its arches, pillars and columns, naturally stimulated sculptural decoration on a scale unknown in European art since Classical times. A hymn needs words, and the monument had to have a message. Figures grew out of the stone shafts on either side of the porches, over the doors lintels and tympana were covered with reliefs, and all over the church figural sculpture appeared on capitals, friezes and corbels. The figures had a definite place in the structure and were themselves composed according to architectural principles. At the same time the architecture became a framework for the sculpture and an integral part of the message it carried. The vault of a cathedral porch supported by statues of the apostles standing on the shoulders of prophets is a symbol in stone of the Christian Church resting on the foundations of the Old Testament. Where Christ is enthroned in the tympanum over a door, the faithful have to pass before his judgment seat in order to enter his house. Old and New Testament stories carved on the capitals of the piers or columns on either side of the nave are the divine revelation on which the walls of the Church rest. The cathedral visibly proclaims the teaching of the Church: it is the Gospel in stone.

Architecture and sculpture were thus fused into an indissoluble unity, both in the aesthetic and in a symbolic sense. The building became an organism no part of which is understandable unless it is seen in relation to the whole. The subordination of details to a monumental scheme is the most significant feature of Romanesque architecture, and of Romanesque art in general.

During the seven or eight centuries which had elapsed since the end of the Classical period, the minor arts had often played a more prominent role than had architecture and its associated crafts; in the northern countries, with their traditional preference for portable objects, the minor arts had been greatly favoured by the Church. It is possible to paint an accurate picture of the early stages of Christian art by relying chiefly on such work as manuscript painting and ivory carving. From the latter part of the eleventh century onwards, however, architecture, large-scale painting and

FIGURE 31

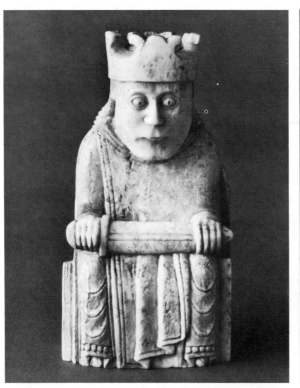
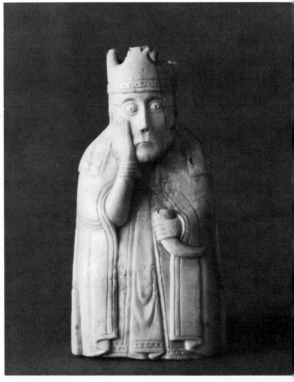
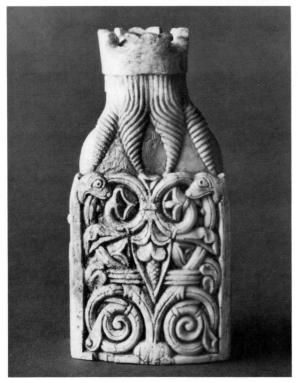
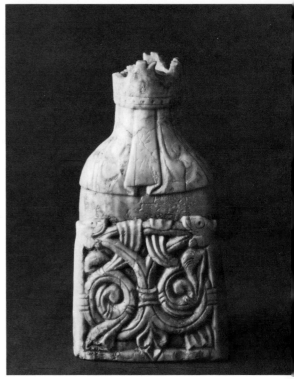

FIGURE 31

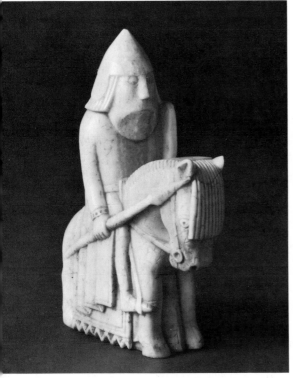 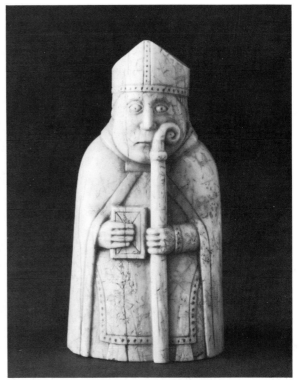

A king, queen, knight and bishop: walrus ivory chess pieces from the Isle of Lewis.
English or Scandinavian, twelfth century. Heights 10 cm, 9·5 cm, 8 cm and 9·5 cm respectively

sculpture came to the fore; a museum exhibition of small isolated objects
from the Romanesque period is far less representative of its subject than
such an exhibition illustrating the art of the preceding centuries.

This qualification must be borne in mind when examples of the minor
arts of the Romanesque period are studied (figs 31, 33–8, pls 13–15).
While they may be superb instances of twelfth-century craftsmanship and
illustrate many of the characteristic features of Romanesque art, they are
not fully representative, nor can they adequately illustrate the various
currents in the art historical evolution of the time. A general impression
is, however, possible with the help of such works, for the principles of
Romanesque style can be seen in the minor arts as well as in architecture
and stone sculpture.

The quest for monumentality was not confined to church architecture
and sculpture: it affected even small objects of the period. The walrus
ivory chess pieces from the Isle of Lewis in the Outer Hebrides (fig. 31),

93

although no more than 10 cm in height, have many of the features of large-scale Romanesque sculpture. In them all forms have been reduced to the simplest elements, and the few parallel lines left to indicate the hang of the garments are incised like ornament into a block; the figures seem to be heavy masses compressed into the smallest possible space, concentrated weight being their chief feature. The eyes are like openings in the surface of the block, through which the compressed energy of the internal mass bursts out. Many works of the period show similar qualities: figures are usually short and heavy, and in many cases their features and garments are indicated by a few lines forming a kind of ornamental net over the mass of shapeless material.

The chess pieces are composed on symmetrical lines and present a more or less flat plane to the spectator. This, too, is typical of Romanesque art: in reliefs, for instance, figures are arranged as simply as possible against a plain background, the third dimension being dispensed with almost entirely. Because of these peculiarities, Romanesque art is often seen as archaic, and there is undoubtedly an air of primeval vigour about much of it. It often displays the neatness and technical purity we associate with archaic art. The demands of naturalism were completely ignored: figures were designed in a purely abstract manner and acquired the exactitude and regularity of ornament. The artists, no longer bound by their Late Antique models, drew their figures with complete freedom and with a feeling for the ornamental beauty of line and curve (figs 36–7, pls 14–15) which seems like a revival of one of the greatest qualities of pre-Carolingian northern art.

The primitive look of Romanesque art is the final outcome of a long and complex development. We saw its features evolving in the tenth and eleventh centuries: it is the fulfilment of tendencies apparent in post-Carolingian European art. We have seen how simplified symmetrical compositions, plain backgrounds, block-like figures, stylised draperies and geometric outlines gradually emerged in Ottonian art. Even more primitive features than those found in Romanesque works had appeared in the art of Spain and its offshoots in southern France. This art, with its robust archaism, is particularly important as a source of Romanesque style, more so in some respects than Ottonian art, which tended to avoid heaviness and concentrated weight. It is therefore not surprising to find the earliest large-scale architectural sculpture of the Romanesque period in the south-west of Europe, in Languedoc and northern Spain. How much this sculpture owed to the previous artistic endeavours in Spain is

FIGURE 32

Limestone capital with the Miraculous Draught of Fishes, from Lewes Priory.
Twelfth century. Height 25·5 cm.

shown by its numerous iconographic links with the Beatus manuscripts. There is therefore a strong direct connection between this extreme primitivism of the tenth and eleventh centuries and the Romanesque art of the twelfth century. To a greater or lesser degree, however, all European countries had inclined to static monumental representation, and the development between the ninth and twelfth centuries may be broadly

95

FIGURE 33

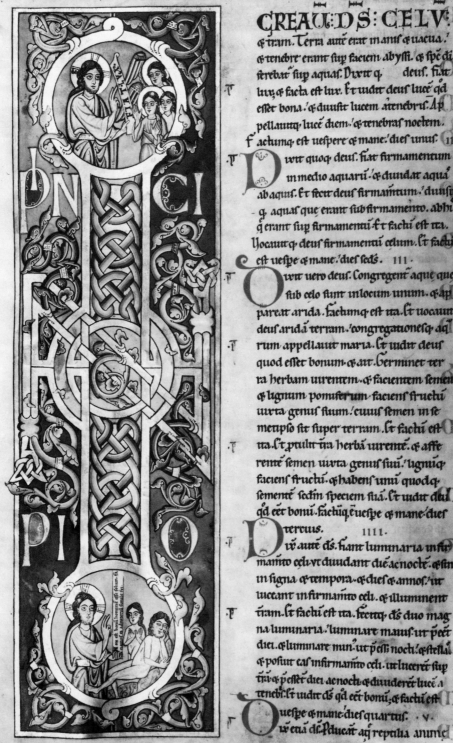

Opening of the Book of Genesis, from the Worms Bible.
Rhenish, mid-twelfth century. Height of panel 39 cm.

summarised as the general transformation of Classical naturalism into abstract regularity, of which the Romanesque primitive style was the final result.

Romanesque archaism was therefore the final outcome and not the initial stage of an evolutionary process. In any case, the term 'archaic' by no means covers all the aspects of twelfth-century style, which has many mature and highly sophisticated features, particularly evident in the structural system of a building and its decoration. A capital from Lewes Priory in Sussex (fig. 32) gives some idea of the subordination of figural sculpture to architectural forms: the Miraculous Draught of Fishes is here represented in a symmetrical composition, and the figures seem to have assumed the role of the volutes which in a Classical capital act as a visual link between the vertical column and the horizontal entablature above.

Even small isolated objects reflect something of this genius for systematic construction. A manuscript page or a liturgical object had become a self-contained whole with a unified scheme: just as the sculpture adorning a cathedral was subject to architectural rules, so the component parts of a painting or carving were subordinated to an overall plan. The beautiful cross enamelled by Godefroid de Claire (pl. 13), with figural scenes separated by decorative panels, provides a good illustration of this principle. A Carolingian and perhaps even an Ottonian artist would have filled the whole cross with a series of narrative scenes, making us lose sight of the underlying geometric form; the use of ornament would have been restricted to the framing of the scenes in accordance with Classical principles. For the twelfth-century artist, however, figural and ornamental panels were of equal value in a rhythmic alternation designed to accentuate the shape of the cross and to articulate it as though it were the ground-plan of a building.

The subordination of all the elements to an overall plan is best seen in the miniatures of the period. It is significant that the most favoured form of manuscript decoration at the time was the historiated initial, an initial containing a narrative scene. Elaborate ornamental initials at the beginning of important sections of text had been a favourite device of artists in the north ever since the great period of Irish and Northumbrian illumination, and figural pages had been added as soon as proper contact with the Mediterranean world had been established; except in a few isolated cases, however, pre-Romanesque miniaturists had never united the two features. The painters of the Winchester School had achieved a fusion of figures and ornamental framework, but only in full-page miniatures carefully

separated from the text. Not until the Romanesque period were text, illustration and ornament subordinated to an overall scheme.

On a page in the Worms Bible (fig. 33), for instance, two figural scenes – the Creation of Light and the Creation of Eve – are enclosed in an ornamental framework of scroll and interlace, and we do not immediately recognise that the whole composition is the letter 'I', which with an interwoven 'N' and with other letters arranged on either side forms the opening words of the Book of Genesis, the text of which continues on the right-hand half of the page. Every book of the Bible is introduced in the same way, not by a full-page miniature but by a composite design of text, ornament and illustration. Miniatures are thus built into the text; they are no longer on separate leaves but have been fused with the script into an indissoluble unit. They are the corner-stones stressing and articulating the structure of the sacred text. Nowhere is there a more apparent desire for comprehensive organisation and architectural order, or a greater aversion to anything loose or undefined.

It was in this spirit that goldsmiths and other metalworkers designed censers, chalices and other liturgical objects in architectural shapes. The domed reliquaries of the Romanesque period and the shrines in basilica form were probably meant to symbolise a sacred building, but the intention was not to produce realistic miniature reproductions of specific churches: what may be called the doll's house taste did not develop until the end of the Middle Ages. In the Romanesque period artists were concerned with monumental rather than realistic effects; this is shown by a censer cover from the Lower Rhine or Meuse (fig. 34). A structure vaguely related to a church with four equal arms grows out of ornamental vegetal scrollwork, while four angels and four evangelist symbols, all much too large to be realistically regarded as inhabitants of the building, are arranged on the four 'facades' and in the four angles. The artist clearly intended the relationship between the various elements to be purely abstract. We know from the classic work on Medieval craftsmanship, the treatise *De diversis artibus* by the monk Theophilus, that the architectural cover of a censer was conceived as a representation of the heavenly Jerusalem, and our example seems to bear this out. At the same time, the architectural form of the censer cover was a perfect vehicle for the monumental effect.

The striving after order and a system was new in art. The transcendental exuberance of the Ottonian period had calmed, and in certain respects this led to a reversal of earlier stylistic tendencies. The establishment of order requires a clear division between component parts. We have seen

FIGURE 34

Bronze-gilt censer-cover.
From the Lower Rhine or Meuse region, late twelfth century. Height 13 cm.

that figures and ornament tended to become confused in the tenth and
eleventh centuries, transforming into an abstract pattern the naturalistic
picture inherited from Classical art. The works of the twelfth century
were founded on this achievement; in fact, without it the strict geometrical
system of Romanesque compositions would be difficult to account for. We
often find a scheme of squares or medallions (fig. 33, pl. 13) cleanly
separating figure and ornament and confining each to a compartment by

itself; within that compartment, however, a Romanesque figure often has more freedom than any Ottonian figure. Whereas the unity of a composition had entirely depended on the figures and ornament, the figure, now securely enclosed in the square or circle assigned to it and thus protected from the interference of other elements and from many of the uncertainties of naturalistic representation, had acquired the freedom to move within the limits imposed. Even with the double obstacle of the architectural system and the integral ornamental treatment, twelfth-century figures often surprise us with a humanity lacking in many earlier works. Mary and Elisabeth greeting one another in the Visitation scene from a German manuscript (pl. 14) have all the qualities of pure ornament and stand like pillars in the centre of an expanse of gold; there is nevertheless real human feeling in the gentleness of their embrace.

A heavier look, more massive proportions and clearly defined outlines often add to this new form of naturalism. Most figures of the Romanesque period stand as though rooted in the earth, whereas those of the tenth and eleventh centuries often balanced precariously, or floated in the air. Despite their remoteness from nature, Romanesque figures are less ethereal: the transcendental had been made concrete.

This new naturalism is particularly striking in the schools of painting and sculpture which fell under fresh Byzantine influence in the course of the twelfth century. Byzantine art, in spite of the conventionalism and hieratic solemnity which it had adopted, still retained something of the Classical concept of the human figure as an independent organism. In an English miniature of about 1200 (fig. 35), contemporary with the purely ornamental style of the Lewis chess pieces, we see a figure of Christ, not just heavy and three-dimensional but organic in its movement and draped in garments which emphasise rather than obscure the structure of the body underneath; the face is softly modelled, well-proportioned and, despite its impersonal gravity, gentle. Byzantine influence is evident, but the arrangement of the page is so regular and the field occupied by the figure so clearly defined that there is no danger of the overall abstract system being upset by the freedom of movement of the body.

The new naturalism in Romanesque art, therefore, only existed by virtue of abstraction. The system of the composition was so clear and flawless and the transformation of the lines of a figure or scene into ornament was so complete that any amount of organic matter could be pressed into the mould. At the moment when the last trace of slavish imitation of Classical models had disappeared, when all the ballast of half-

FIGURE 35

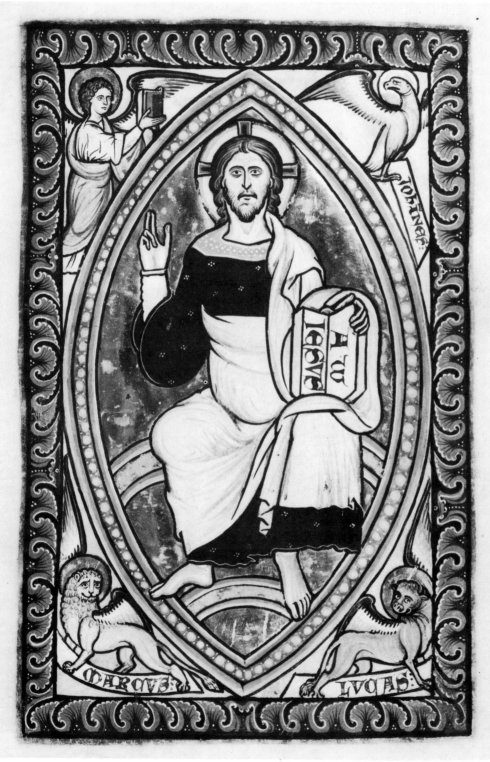

Christ in Majesty, from the Westminster Psalter.
Made for Westminster Abbey, about 1200. Height of panel 16 cm.

FIGURE 36

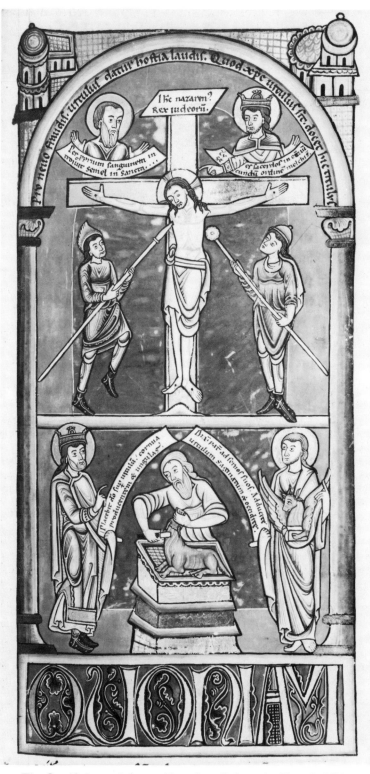

The Crucifixion and the sacrifice of a calf, from the Floreffe Bible.
Made in the Abbey of Floreffe on the Meuse, about 1160. Height of panel 27·5 cm.

understood naturalistic devices which the Carolingian artists had taken over from their Mediterranean models had been jettisoned and the ideal of archaic severity had been reached, Medieval artists could approach the world afresh, confident in the possession of a language which was entirely their own and which enabled them to assimilate any subject. Even then there was little actual study of nature or drawing from life: the main sources of the artist, in the twelfth century no less than at any time since the Classical period, were earlier works of art. The Romanesque artist, however, was no longer tied to his models as a Carolingian or even an Ottonian painter or sculptor had been. It is consequently more difficult to recognise the models which lay behind Romanesque figures and compositions, the more so since there were many new inventions. The artist could represent anything he chose, and he gave it perfect form.

The clearest expression of this new freedom is found in the development of iconography. Twelfth-century art was much richer and more varied in subject-matter than the Christian art of earlier periods had been. Behind this expansion lay the desire to represent Christ and his plan for the redemption of Man. Subjects were chosen for their symbolic meaning, which led to a remodelling of traditional iconographic types and to the creation of many new ones. Above all, it made for an encyclopaedic comprehensiveness illustrated by impressive iconographic cycles which are supreme examples of the structural organisation in Romanesque art.

The best known of these cycles is the so-called typological system, in which an Old Testament event is juxtaposed with a scene from the New Testament in order to show how the one foreshadows the other. Such parallels were loved by the early Fathers of the Church and sometimes found expression in Early Christian art, but from Carolingian times onwards they seldom appeared in iconographic schemes, and it was not until the Romanesque period that a comprehensive typological system was devised. Early Christian and Carolingian artists had endeavoured above all to bring to life a particular Bible story. In Romanesque works, however, the story was often considered of importance only for its bearing on the divine plan for redemption and for its place in the doctrinal scheme. A miniature from a Flemish Bible (fig. 36) showing the sin-offering of the Old Testament in relation to the Crucifixion, of which it was held to be a counterpart, illustrates the principle. The relationship receives particular emphasis through the formal device by which the two scenes are enclosed in the same frame and made part of one symmetrical composition. The enamelled cross by Godefroid de Claire (pl. 13) also has Old Testament

scenes which were regarded by Medieval thinkers as prefiguring the Crucifixion (see notes to pl. 13 on page 127). Most of these scenes had not been represented before the twelfth century.

The systematic elaboration of iconography was not, however, confined to the Bible: it was extended to many other subjects, both religious and secular, which had previously been unknown or regarded as unimportant in Christian art. We now find the signs of the Zodiac, scenes representing the months of the year, the seven liberal arts, and philosophers and poets of the Classical age arranged in series in the arch of a porch, a stained-glass window or an illuminated manuscript, the justification being that they were all symbols capable of being interpreted as part of the divine plan for the redemption of Man. For the same reason we find such seemingly secular subjects as animal scenes: for instance, on the pages of a bestiary (fig. 37), a Medieval text-book of zoology with descriptions of various animals and their habits. Fantastic and even childish from a modern scientific standpoint, to the Medieval reader such texts related the natural world to Christ and the teaching of the Church (see notes to fig. 37 on page 123). Secular art barely existed – or, rather, the distinction between sacred and secular was meaningless, since everything proceeded from Christ.

In the twelfth century, therefore, the didactic tendency, that desire to convey a definite message which had influenced all artistic activity since the Late Antique period, found its ultimate fulfilment. From the propagandist art of the late Roman emperors and the symbolic language of the earliest Christian monuments, the way had led to the vivid narrative style of early Byzantine and Carolingian art and to the ecstatic expressionism of the Ottonian age. Now, in the twelfth century, religious fervour was rationalised and presented in the form of a strict system which took in the whole world and saw everything in relation to a central idea. Romanesque art thus combined perfect abstract form and profound spiritual meaning. The two aims of earlier times, to create pure ornament and to convey a particular message, were finally reconciled. Every theme, whether sacred or secular, was subjected to an inflexible transcendental system which was at the same time an entirely harmonious pattern.

The country which more than any other contributed towards the systematic organisation of iconography and clear ornamental beauty of style in Romanesque art was France. Having remained in the background during the tenth and eleventh centuries, when many other countries experienced intense creative activity, France suddenly assumed the lead at the end of

FIGURE 37

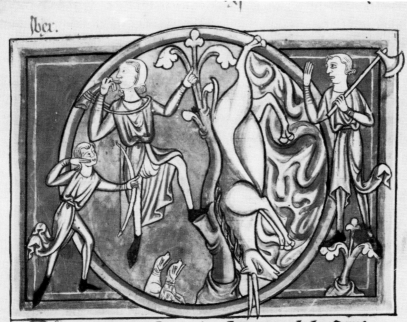

Est animal quod dicitur Ibex duo cornua habens. qua
rum tanta uis est ut si ab alto montis ad ima demsi
sus fuerit. corpus eius totum his duobz cornibz sustetetur
illesum. Significat autem eruditos homines. qui duorum
testamentorum consonantia quicquid eis aduersi accident
quasi quodam salubri temparmento temperare solet. & ueld
duobz cornibz sultī bona q ppetuo ueteris testamti ac euīglice
lectionis attestatione sustentant.

Page from a bestiary.
English, late twelfth century. Width of panels 15·5 cm.

the eleventh century and retained it throughout the Romanesque and Gothic periods. On French soil the Ottonian genius for subtle expressiveness and abstract order and the robust and primeval archaism of Spanish art became united, and here also took place in the last decades of the eleventh and the earlier part of the twelfth century the astonishing architectural development which led to the elaborate organism of the Romanesque cathedral, with its arcades, shafts and ribbed vaults. Here, too, monumental sculpture was reborn and became an essential part of the architectural system. The new evolution did not remain within the borders of France, however: it spread to England, Germany and Italy. Romanesque art was international, the art of Europe in the twelfth century.

There were, it is true, regional differences, and the pace of development was not the same everywhere. France, the originator of the new art, made rapid strides towards perfection, pressing forward into unknown territory towards the Gothic style, which was in vigorous growth in the second half of the twelfth century. Germany, on the other hand, lagged behind; Romanesque art took on a hybrid and baroque richness here, and, unlike France, Germany made no progress towards Gothic art until the middle of the thirteenth century. Distinctive characteristics were also caused by the different stylistic traditions of the various countries. In English works of the twelfth century, for instance, such as a fragment of ivory inhabited scroll (fig. 38), we can find traces of the diffuse, sketchy and nervously exuberant manner of Winchester ornament. In other English Romanesque works we find the predilection for the grotesque and for exaggerated movements and gestures which had been typical of eleventh-century drawing: illustrations in a twelfth-century psalter (pl. 15) from St Swithin's Priory, Winchester, contain figures worthy of Breughel or Bosch. On the whole, however, the features common to all Romanesque art are much more conspicuous than regional ones.

Even Byzantine art, although outside the sphere where the term 'Romanesque' applies, was not untouched by the development in the West. Byzantium, as might be expected, followed its own traditions and continued to serve as a storehouse of Classical style: even in twelfth-century miniatures (fig. 39) we find narrative scenes executed in what is still essentially a Late Antique style and technique, with scenery, space, and impressionistic highlights giving form to folds, faces and mountain crags. Byzantine art never underwent the revolutionary changes of western Early Medieval art; it lacked the fermenting process through which the taste for abstraction and ornament led to a complete transformation of Classical models.

FIGURE 38

Fragment of an ivory inhabited scroll.
English, twelfth century. Height 6 cm.

Continued adherence to traditional types and techniques has always dis-
tinguished Byzantium from the West, and development in the centuries
following the Macedonian 'renaissance' largely consisted in stereotyping
the traditional style. It is difficult, however, to distinguish between this
inherent sterility and the positive tendency towards hieratic representation,
which – ever present in Byzantine art – had become conspicuous in the
works of the tenth and eleventh centuries, forming a bond between eastern
and western art. As this tendency increased in the twelfth century, Byzantine
works acquired their own monumental austerity and archaic simplicity,
generally comparable to that of western Romanesque art. Expressed in
such general terms, this may seem to indicate no more than a vague and
perhaps accidental parallel, but the connection becomes more definite
with the realisation that during the period Byzantine frescoes and mosaics
developed increasingly monumental compositions and systematic arrange-
ments in conformity with the architecture; like western Romanesque
painting and sculpture, they must be regarded as becoming more and
more part of the architectural organism. When we find in twelfth-century

Byzantine manuscripts narrative scenes no longer occupying a page of their own but inserted into elaborate ornament at the beginning of a chapter – a practice previously unknown – we cannot help recalling the very similar principles evolved in the West (compare fig. 39 with fig. 33). While the hieratic tendencies of the late tenth and eleventh centuries seem to have been, at least to some extent, exported from Byzantium to the West, the systematic organisation of figures and ornament in twelfth-century Byzantine art is an indication of western Romanesque taste making some impression at least on contemporary Byzantium. The essential character of Byzantine art was unaffected, however; it remained independent, whereas the western countries shared a stylistic unity based on common foundations.

There are sound historical reasons for the unity of Romanesque art in the West. The styles of the tenth and eleventh centuries had been the result of the spontaneous efforts of rulers and of monasteries in the different countries. Behind the art of the twelfth century, on the other hand, stood the Church at the height of its power: it is the period in which the long drawn-out struggle for supremacy over the German emperors ended in victory for the popes, and the period in which the internal strength of the Church reached its peak after fundamental and drastic reforms promoted by the great monastic orders in France. From there the religious ideal spread all over Europe: emperors, kings and knights united in the cause of Christ and embarked on the great adventure of the Crusades.

This is the background against which Romanesque art must be viewed, the background to its essential unity and also to its iconography and style. The encyclopaedic character of its images, its elaborate iconographic system, the formal arrangement of its compositions and the feeling of calm dignity and absolute finality which it creates are all expressions of a deep desire to represent the world as subject to the supreme and eternal power of Christ and of the Church which represents him. The artist aimed at subordinating the material world to a spiritual and transcendental order of which the Church was the centre and the guardian; he was doing in art what Scholasticism, then approaching its zenith, was doing in philosophy.

Romanesque art represents the fulfilment of the task undertaken by artists when, at the end of the Classical period, they began to lose touch with naturalism and broke up the harmony of Greek art so that such new creeds as the cult of the emperor could be given expression. A long and arduous path had to be trodden before the new transcendental tendencies,

FIGURE 39

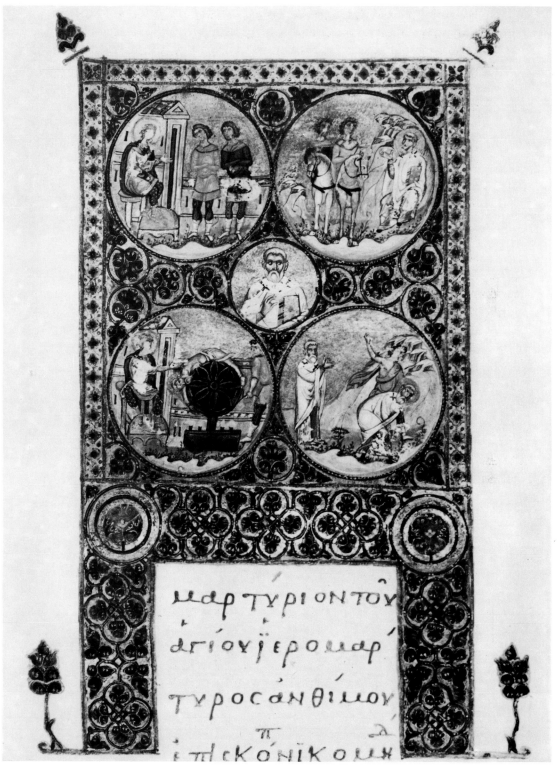

The martyrdom of St Anthimus, from a Byzantine manuscript.
Eleventh or twelfth century. Height of panel 18 cm.

which at first seemed almost entirely negative and merely a symptom of decadence, had assumed stylistic forms which gave full and positive expression to a new conception of the world. The decisive moment came when, in the Carolingian age, the Mediterranean heritage was taken over by the peoples of the north, whose tradition of wholly abstract and ornamental art enabled them to give visual form to purely transcendental relationships. By applying in the following centuries the principles of this art to the descriptive painting and sculpture taken over from the south, a perfect subordination of matter to abstract harmony was effected. This is the essence of Romanesque art.

And so, during the early Middle Ages – which are still too often seen as a mere hiatus – the basis of European art was completely changed, and a new and great ideal found full expression. Romanesque art was not a beginning but a final synthesis. While Gothic art continued along the same path, it soon began to acquire a romantic flavour and a mysticism of an individual kind (pl. 16), which, although tending to emphasise the transcendental character of Medieval style, contained the germ which would eventually destroy its austere and impersonal greatness.

THE PLATES

PLATE I

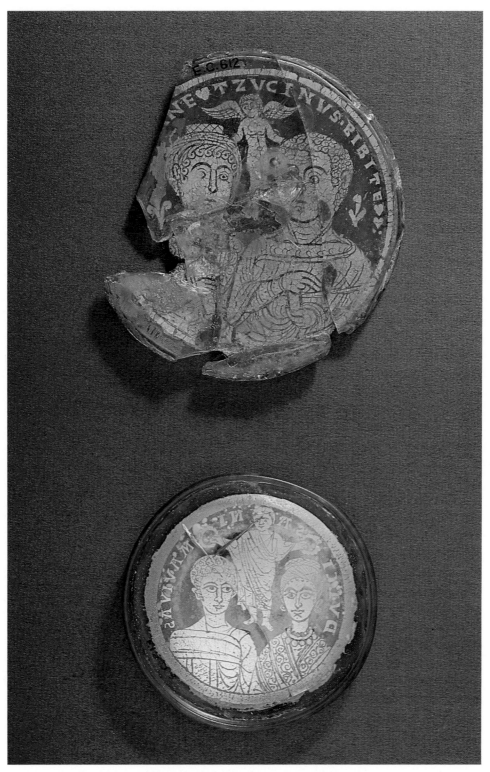

Gold-glass from the Roman catacombs.
Fourth century. Diams 7 and 5·5 cm. (See page 14)

PLATE 2

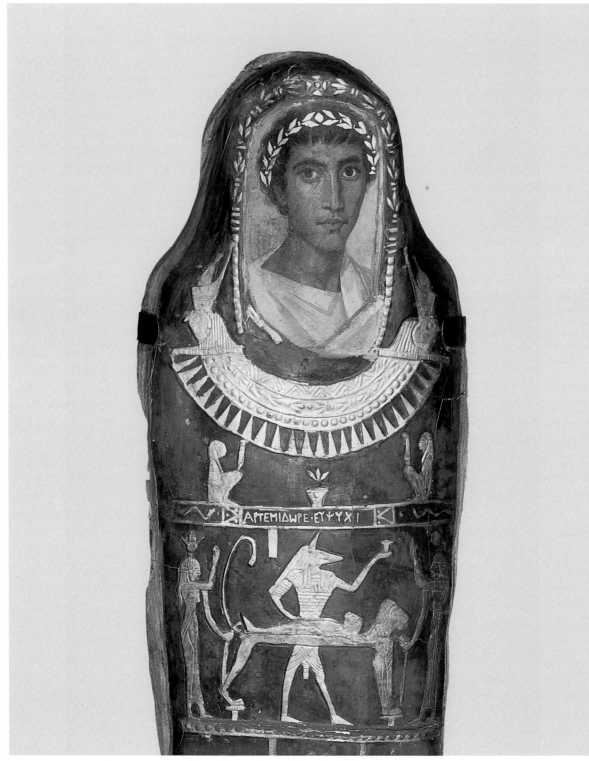

Mummy-case from the Fayyum.
Second century. Width at shoulders 42·5 cm. (See page 17)

PLATE 3

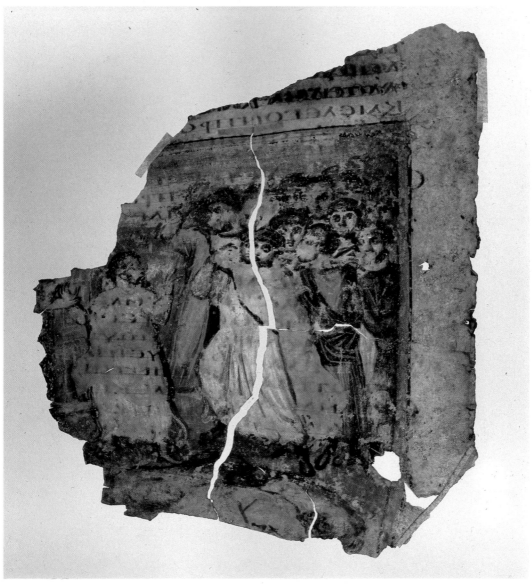

Lot defending his house, from the Cotton Genesis.
Probably from Egypt, fifth or early sixth century. Width 9·5 cm. (See page 31)

PLATE 4

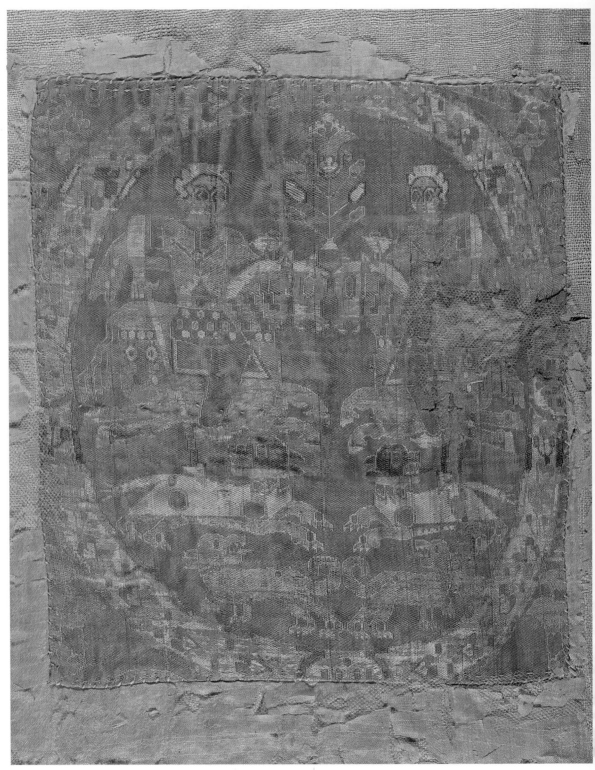

Hunting scene woven in silk.
Coptic, seventh century. Height 24 cm. (See page 42)

PLATE 5

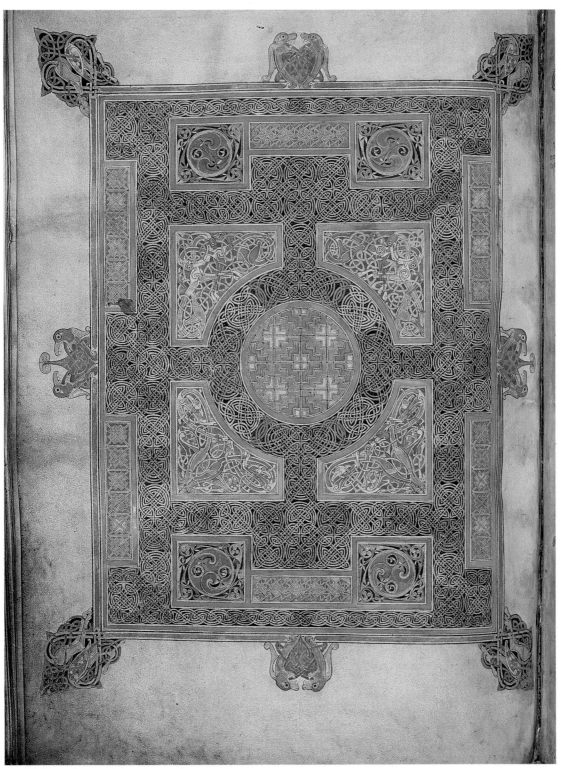

'Carpet-page' from the Lindisfarne Gospels.
Northumbrian, late seventh century. Height of panel 24 cm. (See page 49)

PLATE 6

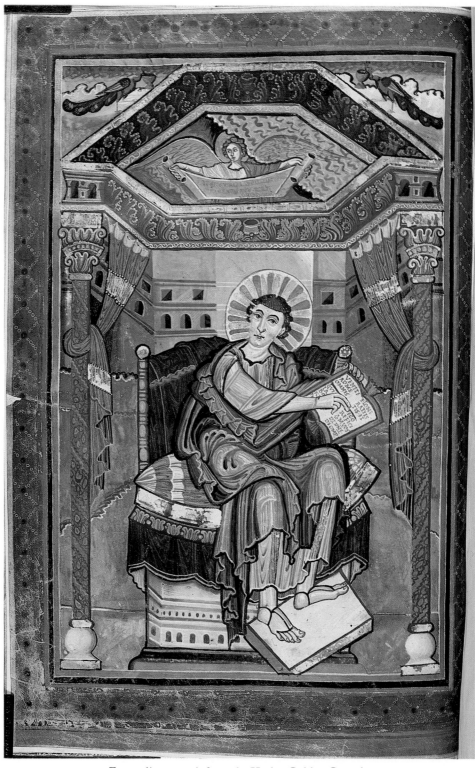

Evangelist portrait from the Harley Golden Gospels.
Ada Group, early ninth century. Height of page 36 cm. (See page 56)

PLATE 7

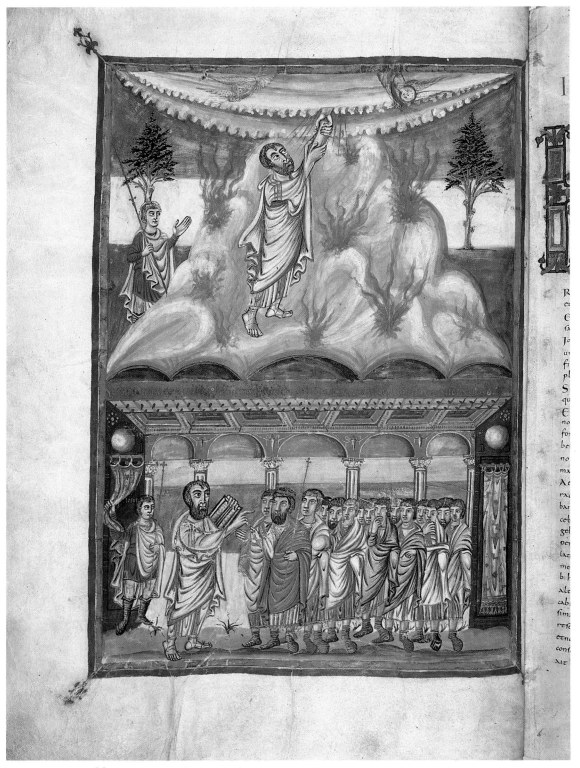

Moses receiving the Law and teaching it to the Israelites, from a Tours Bible.
Between 834 and 843. Height of panel 40·5 cm. (See page 58)

PLATE 8

Opening of St Luke's Gospel, from the Harley Golden Gospels.
Ada Group, early ninth century. Height of panel 32·5 cm. (See page 62)

PLATE 9

Evangelist portrait from a Byzantine Gospel-book.
Tenth century. Height of panel 17 cm. (See page 72)

PLATE 10

Evangelist portrait from the Grimbald Gospels.
Winchester School, early eleventh century. Height of frame 21 cm. (See page 75)

PLATE II

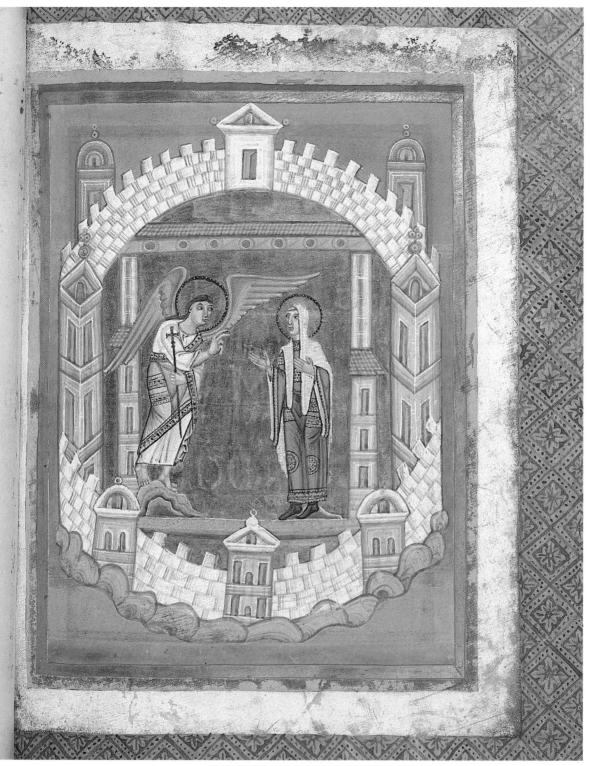

The Annunciation, from an Ottonian Gospel-book.
Early eleventh century. Height of panel 18 cm. (See page 83)

PLATE 12

The Four Horsemen of the Apocalypse, from the Silos Apocalypse.
Spanish, between 1091 and 1109. Height of panel 32 cm. (See page 87)

PLATE 13

Enamel cross with Old Testament scenes prefiguring the Crucifixion.
Meuse region, third quarter of twelfth century. Height 37·5 cm. (See page 97)

PLATE 14

The Visitation, from a German manuscript.
Twelfth century. Height of panel 21·5 cm. (See page 100)

PLATE 15

Passion scenes from the Winchester Psalter.
English, mid-twelfth century. Height of panel 27·5 cm. (See page 106)

PLATE 16

St Cuthbert and companions, from a manuscript of Bede's life of the saint.
English, late twelfth century. Height of panel 10·5 cm. (See page 110)

NOTES ON THE ILLUSTRATIONS

FIGURE 1 Limestone sepulchral half-figure.
page 10

 The bearded man, dressed in a toga, is identified by an inscription in Palmyrene as Hayran, son of Maryon.

 Height 63·5 cm. Second century. From Palmyra (Syria).
British Museum, Department of Western Asiatic Antiquities, no. 125032.

FIGURE 2 The Projecta Casket, from the Esquiline Treasure.
page 13

 On the front of the body of the embossed silver, partly gilt, casket the owner is depicted at her toilet, sitting under an arcade attended by two servants; on the remaining sides of the body are servants carrying various objects. On the front of the lid Venus is seen seated in a shell dressing her hair, assisted by two Tritons; the short sides of the lid show Nereids and sea-monsters, and on the remaining side is a representation of a procession to the baths. On the top are half-figures of a couple in a wreath held by two Cupids. The casket has the engraved inscription SECVNDE ET PROIECTA VIVATIS IN CHRISTO ('Secundus and Projecta, may you live in Christ').

 Length 56 cm. Second half of the fourth century. Part of a large silver treasure found on the Esquiline Hill in Rome.
 British Museum, Department of Medieval and Later Antiquities, no. 66,12–29,1.
Catalogue of Early Christian antiquities, no. 304; *The Esquiline Treasure*, no. 1.

FIGURE 3 Limestone tombstone.
page 18

 In the upper zone two figures, possibly Castor and Pollux, with their horses flank a deity; below are two men sacrificing, a man leading a bull, another man following him with a basket, and three figures praying.

 Height 78·5 cm. Probably second century. From near Carthage (Tunisia).
British Museum, Department of Western Asiatic Antiquities, no. 125345.

FIGURE 4 Limestone ossuary.
page 19

 The casket-shaped box with a coped lid is carved with conventional

113

ornament consisting of foliate, rosette and architectural motifs.

Length 83 cm. Probably first century. Jewish, from Jerusalem.
British Museum, Department of Western Asiatic Antiquities, no. 126392.

FIGURE 5 Ivory panel. The apotheosis of an emperor.
page 23

Below, a funeral carriage is drawn by four elephants, with the figure
of an emperor seated under a canopy. In the background a naked deity, perhaps
the deified emperor, rises from a draped pyre in a quadriga, with two eagles
accompanying him. Above, the emperor is carried to heaven by two winged genii,
with five men watching from a cloud; to the right is a bust of the sun-god behind a
section of the Zodiac.

Height 30 cm. Late fourth century. Probably carved in Rome.
(The monogram in the centre of the openwork volute *can* be deciphered as
SYMMACHORVM. The Symmachi were an immensely gifted senatorial family who
played a leading role in the defence of their pagan religion at a time when the Christian
Church was growing in power. The Symmachus family is known to have commissioned at
least one ivory, albeit with a much more Classical 'feel' than this panel.)
British Museum, Department of Medieval and Later Antiquities, no. 57,10–13,1.
Catalogue of ivory carvings, no. 1.

FIGURE 6 Four sides of an ivory box. Scenes from the Passion.
pages 28–9

(i) The Judgment of Christ and the Carrying of the Cross. On the
left, Pilate washes his hands (Matthew 27:24); in the centre, escorted by a soldier,
Christ carries the cross. On the right, to his accuser, Peter denies knowing Christ;
above his head is the cock (Matthew 26:69–75). (ii) The death of Judas and the
Crucifixion. On the left, Judas is hanging from a tree, the thirty pieces of silver
beneath his feet (Matthew 27:5). On the right is Christ, crucified between the
Virgin and John on the left and, to the right, the soldier Longinus, who is piercing
Christ's side (John 19:34). (iii) The Holy Women at the Sepulchre. Two Marys
(Matthew 28:1) and two sleeping soldiers are grouped round the Sepulchre, the
open doors of which reveal part of the empty coffin. (iv) The Incredulity of
Thomas. The risen Christ stands in the centre of a group of apostles, his arm
raised to exhibit the wound in his side. Thomas is invited to probe Christ's
wounds (John 20: 24–9).

Width of each panel 10 cm. Early fifth century. Probably carved in Rome.
British Museum, Department of Medieval and Later Antiquities, nos 56,6–23,4–7.
Catalogue of Early Christian antiquities, no. 291; *Catalogue of ivory carvings*, no. 7.

FIGURE 7 Fragment of a leaf from the Cotton Genesis, an illustrated
page 33 Bible in Greek.

The fragment, illustrating Genesis 19:5ff., shows Sarah.

Fragment 14·5 × 6·5 cm. Fifth or early sixth century. Probably from Egypt.
British Library, Department of Manuscripts, Cotton MS Otho B.VI, fragment 3.

FIGURE 8 Leaf of an ivory diptych. The figure of an archangel.
page 33

Holding an orb and a staff, the archangel stands on a flight of steps underneath an ornate arch. The Greek inscription can be translated as 'Receive these, and having learnt the cause. . . .'

Height 41 cm. Sixth century. Probably carved in Constantinople.
British Museum, Department of Medieval and Later Antiquities. *Catalogue of Early Christian antiquities*, no. 295; *Catalogue of ivory carvings*, no. 11.

FIGURE 9 Silver dish.
page 34

The embossed centrepiece shows a Cupid with a trident fighting a sea-monster. The scene is surrounded by a band of chased foliate design, and engraved ornament decorates the rest of the face and the underside.

Diameter 13 cm. Seventh century. Byzantine.
British Museum, Department of Medieval and Later Antiquities, no. 1969,12–3,1 (transferred from the Department of Greek and Roman Antiquities).

FIGURE 10 Silver bowl from the First Cyprus Treasure.
page 34

In the centre is the half-figure of St Sergios or St Bacchos, carrying a cross and surrounded by an ornamental border in niello; the rim is chased with a foliate frieze. On the underside are five control-stamps, probably of Constans II (641–668).

Diameter 24·5 cm. Probably mid-seventh century. Part of a Byzantine silver treasure found at Lambousa, near Kyrenia, Cyprus.
(The *maniakion*, the ornament worn round the neck, identifies the saint as a member of the Imperial Guard. This in turn points to Sergios or his second-in-command, Bacchos, martyred together early in the fourth century.)
British Museum, Department of Medieval and Later Antiquities, no. 99,4–25,2. *Catalogue of Early Christian antiquities*, no. 398.

FIGURE 11 Gold ornament. Hunting scene.
page 34

The figures are engraved and reserved against a decorative pierced background; the plaque has a heavy beaded border.

Height 5 cm. Fourth century. From Asia Minor, found with coins of Constantius (337–361).
British Museum, Department of Medieval and Later Antiquities, no. AF 332. *Catalogue of Early Christian antiquities*, no. 252.

FIGURE 12 Canon-tables from a Byzantine Gospel-book.
page 36

Part of the Eusebian concordance of biblical references is set in an

ornamental arcade. Beneath the main arches are medallions containing busts, possibly those of apostles.

Leaf 21·5 × 15·5 cm. Seventh century. Possibly made in Constantinople and said to have belonged later to one of the monasteries on Mount Athos, Greece.

(The cross-referencing of the Gospels in common use was devised by Eusebius (263–339), the historian of Christian Antiquity and Bishop of Caesarea from about 313.)

British Library, Department of Manuscripts, Add. MS 5111, folio 11.

FIGURE 13 Ivory panel. The Adoration of the Magi and the Nativity.

page 37

Above, grouped round the Virgin and Child, are an angel with a cruciform staff and the three Magi offering their gifts in veiled hands. Below, the Virgin reclines on a mattress, and the Child lies in the manger between the ox and the ass with the Star of Bethlehem above; in front of the manger, a kneeling woman holds out her withered hand towards the infant Christ.

Height 21·5 cm. Sixth century. Carved in the eastern Mediterranean region, probably in the Holy Land.

(The story of Salome, who attempted a post-natal manual test of Mary's virginity and had her hand withered for her presumption and disbelief, is told in the apocryphal *Protoevangelium Iacobi*, 19:3–20:4. The story was later applied to a midwife.)

British Museum, Department of Medieval and Later Antiquities, no. 1904,7–2,1. *Catalogue of ivory carvings*, no. 14.

FIGURE 14 Pewter pilgrim-flask.

page 40

On either side, stamped in relief, is a New Testament scene below a cross in an arch. *Obverse*: the Holy Women at the Sepulchre. In a symmetrical composition, the two Marys (Matthew 28:1) and the angel flank the Sepulchre. Below are two birds, symmetrically placed to either side of a plant; above is an inscription reading 'The Lord is risen'. Round the circumference of the flask is the inscription 'The Lord's blessing from the holy places'. *Reverse*: the Incredulity of Thomas. Christ, standing in the very centre of an interior scene, takes Thomas by the wrist and invites him to probe the wound made by Longinus' spear. The other eleven apostles look on. The inscription above reads 'My Lord and my God' (John 20:28).

Height 7 cm. About 600. From the Holy Land (see the longest of the three inscriptions); found at El Azam, Egypt.

British Museum, Department of Medieval and Later Antiquities, no. 1902,5–29,24.

FIGURE 15 Limestone tombstone.

page 43

Above is a cross between two columns, and an inscription in Greek commemorating Sophrone. Below, above a branch, is a bird with a cross in its beak; between its wings it holds a medallion with a cross.

Height 81·5 cm. Seventh century. Coptic, from Egypt.

British Museum, Department of Egyptian Antiquities, no. 1790. *Catalogue of Early Christian antiquities*, no. 942.

FIGURE 16 Gold buckle.
page 47

> The face of the buckle, the revolving plate at the base of the tongue and the hinged loop are decorated with interlaced animal ornament, some details picked out in niello.

Length 13 cm. Early seventh century. From Sutton Hoo, Suffolk: part of the grave-goods from the famous ship-burial.
British Museum, Department of Medieval and Later Antiquities, no. 1939,10–10,1.
Sutton Hoo Handbook, third edition, p. 108f.; *The Sutton Hoo Ship-Burial*, vol. 2, p. 536ff.

FIGURE 17 Miniature from the Lindisfarne Gospels.
page 48 St John the Evangelist.

> The evangelist is shown seated on a stool and holding a scroll; above his head is his symbol, the eagle, holding a book.

Panel 23·5 × 18·5 cm. Late seventh century. Northumbrian.
According to a tenth-century note, these Gospels were written by Eadfrith, who was Bishop of Lindisfarne from 698 until 721.
British Library, Department of Manuscripts, Cotton MS Nero D.IV, folio 209b.

FIGURE 18 Miniature from the Harley Psalter.
page 53 Illustration of Psalm 104.

> Above, the Lord, accompanied by his angels, his 'ministers', walks 'upon the wings of the wind', represented by human heads blowing on the earth. To the right and left are sun, moon and stars ('He appointed the moon for seasons: the sun knoweth his going down'). Below are shown the Lord's creations. To the left are mountains, valleys and springs which 'give drink to every beast of the field', 'Fowls of the heaven . . . which sing among the branches', and birds which make their nests in 'the Cedars of Lebanon'. A ploughman symbolises Man, who 'goeth forth unto his work and to his labour', while three men seated at a table are served by two attendants with 'wine that maketh glad the heart of man, and oil to make his face to shine'. In front of this scene is the 'great and wide sea'; 'There go the ships: there is the leviathan'. To the right 'young lions roar after their prey'; below are high hills, which 'are a refuge for wild goats', and the Psalmist, his right hand raised towards the Lord, his left indicating the Creation.

Width of page 31·5 cm. About 1000. A copy, probably made at St Augustine's Abbey, Canterbury, of the Carolingian Utrecht Psalter of around 820.
British Library, Department of Manuscripts, Harley MS 603, folio 51b.

FIGURE 19 Ivory panel. The Miracle at Cana.
page 54

> Above, to the left, Christ with three companions converses with the Virgin; to the right, two servants wait on three guests feasting at a table. Below, Christ is in conversation with the master of the house, while two servants fill the 'six water-pots of stone' (John 2:6).

Height 14·5 cm. Third quarter of the ninth century. Carolingian, 'Liuthard Group'.

(The ivory exactly fits a depression in the cover of a Gospel-book in Darmstadt, Hessische Landesbibliothek, Cod. 746, written and illuminated by a Liuthard.)

British Museum, Department of Medieval and Later Antiquities, no. 56,6–23,20. *Catalogue of ivory carvings*, no. 44.

FIGURE 20 Leaf of an ivory diptych. Scenes from the New Testament.
page 57

At the top, the Annunciation: the Virgin sits on a cushioned chair, with Gabriel approaching from the left. In the middle, the Nativity: the Virgin lies on a mattress within a walled enclosure, Joseph sits outside, and in the background is the infant Christ in the manger, with the ox and the ass in attendance. At the bottom, the Adoration of the Magi: the Virgin is seated on a chair to the left, with Christ on her lap and the three Magi approaching from the right, guided by the Star of Bethlehem. Many of the figures retain traces of colouring, chiefly red, blue and gold.

Height 16·5 cm. Early ninth century. Carolingian, 'Ada Group', probably carved at Aachen.

British Museum, Department of Medieval and Later Antiquities, no. 56,6–23,17. *Catalogue of ivory carvings*, no. 42.

FIGURE 21 The Lothar Crystal.
page 60

The scenes engraved on this disk of rock-crystal illustrate the History of Susanna, from the Apocrypha. At the top are Susanna (S[AN]C[T]A SVSAN[N]A) in an enclosed garden, carrying two vessels for unguents, and two elders, who 'rose up, and ran unto her' (SVRREXER[VNT] SENES); to the right, two servants respond to her cry ([AC]CVRRER[VNT] SERVI). Below, to the right, the two elders, in the house of Joachim, send for Susanna (MITTITE AD SVSANNA[M]); below, the two elders lay their hands on Susanna's head (MISER[VNT] MANVS) in the prescence of the people. At the bottom of the crystal to the right, are Susanna, 'led to be put to death' (CV[M]Q[VE] DVCERE[TVR] AD MORTE[M]), having been falsely accused of adultery, and Daniel, 'Who cried with a loud voice, I am clear from the blood of this woman', while two of the people turn towards him ('What mean these words that thou hast spoken?'). To the left of this group, Daniel examines one of the elders 'waxen old in wickedness' (INVETERATE DIER[VM] MALOR[VM]), with two onlookers expressing approval. Above, on the left, Daniel traps the second elder into a conflicting account and convicts him of false testimony (RECTE MENTITVS ES), while three figures express indignation. Above this scene, the two elders are stoned to death (FECER[VNT]Q[VE] EIS SICVT MALE EGERANT). In the centre medallion, Susanna with two companions stands before a judge seated under a canopy. The inscription reads ET SALVATVS EST [SANGVIS] INNOXIVS IN D[IE ILL]A: 'Thus the innocent blood was saved the same day'. Round the top of the medallion is inscribed LOTHARIVS REX FRANC[ORVM F]IERI IVSSIT (Lothar, King of the Franks, ordered this to be made).

Diameter 11·5 cm. The Lothar of the inscription must be either the Carolingian emperor (843–855) or, more probably, his son of the same time (855–869). From the tenth century

until the French Revolution the crystal was in the Abbey of Waulsort, on the Meuse.

(Lothar II tried to have his marriage annulled on the grounds of his wife's alleged adultery so that he could marry his mistress. He was eventually forced to take back his wife in 865, but if this is the occasion commemorated by the crystal it is unlikely that he would of his own free will have commissioned what amounted to a confession of guilt, since he continued for the rest of his life to seek the annulment.)

British Museum, Department of Medieval and Later Antiquities, no. 55,12–1,5. *Catalogue of post-Classical engraved gems*, no. 559.

FIGURE 22 Page from a Gospel-book.

page 61

The page is intended to be read as the first two words of St Luke's Gospel, QVONIAM QVIDEM, in an ornamental frame. The first 'Q' forms a large initial with interlace and animal ornament.

Panel 22·5 × 15 cm. Ninth century. Carolingian, Franco-Saxon School, probably made in north-eastern France or Belgium.
British Library, Department of Manuscripts, Egerton MS 768, folio 2.

FIGURE 23 Ivory diptych. Scenes from the life of Christ.

pages 64–5

Above, left, the Raising of Lazarus from the dead (John 11). Christ raises Lazarus, 'bound hand and foot with grave-clothes: and his face was bound about with a napkin'. Between Christ and Lazarus stands Martha, and at Christ's feet kneels Lazarus' other sister, Mary ('Then when Mary was come where Jesus was, and saw him, she fell down at his feet . . .'). Behind Christ, some of his disciples. Below, left, the Healing of the Blind Man. Christ, in the midst of his disciples, anoints the eyes of the blind man (John 9:6). The architecture to the right may represent Bethsaida (Mark 8:22). Above, right, the Transfiguration. Christ, in a mandorla beneath the hand of God, is flanked by Moses and Elias 'talking with him' (Matthew 17:3), while Peter, James and John are shown below, two of them in attitudes illustrating the text 'they fell on their face, and were sore afraid' (Matthew 17:6). Below, right, the Entry into Jerusalem. Christ, riding on an ass, is accompanied by disciples, while 'a very great multitude spread their garments in the way' and 'others cut down branches from the trees', with which to strew Christ's path (Matthew 21:8).

Height of each panel 16·5 cm. Tenth century. School of Metz.
British Museum, Department of Medieval and Later Antiquities, no. 56,6–23,15. *Catalogue of ivory carvings*, no. 46.

FIGURE 24 Ivory panel. The Nativity.

page 68

In the centre, the Virgin reclines on a mattress; behind her, the infant Christ lies in a manger of masonry with the heads of the ox and the ass showing above it. At the top, to the left, 'a multitude of the heavenly host' behind the Angel of the Lord, who addresses the shepherds (Luke 2:8–14). In the foreground sits Joseph; to the right, a midwife bathes the holy infant in a two-handled vessel, besides which stands a ewer in the shape of a bird.

Height 11·5 cm. Tenth century. Byzantine.
British Museum, Department of Medieval and Later Antiquities, no. 85,8−4,4. *Catalogue of Early Christian antiquities*, no. 33; *Catalogue of ivory carvings*, no. 19.

FIGURE 25 The Borradaile Triptych.

page 70

The centre panel of the ivory triptych is carved with the Crucifixion between the Virgin and St John and, above, the half-figures of the archangels Michael and Gabriel. On the left wing are representations of the saints Cyrus, George, Theodore Stratelates, Menas and Procopius; on the right, John of Syria (companion-saint to Cyrus), Eustachius, Clement of Ancyra, Stephen (probably of Antioch) and Cyrion.

Height 27·5 cm. Mid-tenth century. Probably carved in Constantinople.
(On the back of each wing – on the outside of the triptych when closed – is a cross with a medallion in the centre, above and below, in which are busts of the saints Joachim, Anna, Basil, James the Persian, Barbara and Thecla.)
British Museum, Department of Medieval and Later Antiquities, no. 1923, 12−5,1.

FIGURE 26 Marble panel. Allegorical representations of animals.

page 71

In the centre, an eagle grasps a serpent; to either side, in almost symmetrical arrangement, is an eagle with a hare in its talons.

Length 241 cm. Tenth or eleventh century. From Constantinople.
British Museum, Department of Medieval and Later Antiquities, no. 1924,10−17,1.

FIGURE 27 Page from a psalter in Greek. The manna and the quail.

page 73

The miniatures in the margins illustrate Psalm 78:24ff. Above, to the right, two Israelites collect into baskets the manna falling from heaven, represented by a section of the globe. Below, a flight of quail move towards the left, where one Israelite is seen plucking a bird while another roasts four on a spit over an open fire.

Page 11·5 × 9 cm. Eleventh century. Byzantine.
British Library, Department of Manuscripts, Add. MS 40731, folio 128.

FIGURE 28 Miniature from a Late Anglo-Saxon manuscript.
page 77 St Pachomius receiving the Easter Tables.

The pen drawing illustrates a collection of tracts and tables for calculating the date of Easter. St Pachomius and three of his monks prostrate themselves before an angel from whom they receive the Easter Tables; to the right is a church.

Width of miniature 12 cm. Shortly before 1058. Probably from Christ Church, Canterbury.
British Library, Department of Manuscripts, Cotton MS Caligula A.XV, folio 122b.

FIGURE 29 Ivory panel. The Raising of the Widow's Son.
page 80

Christ, followed by a group of disciples, touches the bier as it is carried out of the city of Nain (Luke 7:11–15), accompanied by the dead man's weeping mother and another mourner.

Height 12·5 cm. About 970. Ottonian, possibly carved in Milan.

(There are fifteen other plaques similar in shape, size and style, four of which were re-used on the cover of a manuscript associated with Magdeburg. This has led to the theory that the sixteen surviving panels, one of which depicts an Ottonian ruler presenting a church building to Christ, originally decorated an altar or a pulpit in Magdeburg Cathedral, the construction of which was begun under the patronage of Otto the Great in 955. Magdeburg became the seat of an archbishop in 968; Otto died five years later. There are stylistic similarities between these Magdeburg plaques and ivories known to have been carved in Milan during the Ottonian period.)

British Museum, Department of Medieval and Later Antiquities, no. 56,6–23,25. *Catalogue of ivory carvings*, no. 55.

FIGURE 30 Illustration from an Exultet roll. Adam and Eve.
page 85

To the left stands the Tree of Knowledge, round which is coiled the serpent, its tail round the foot of Eve, who picks the apple with her right hand and, with her left, puts it in Adam's mouth. To the right is the Tree of Life.

Height of figures about 13 cm. Second half of the eleventh century. From Montecassino, southern Italy.

(The text is apparently upside down because, while it was being read by the priest, the scroll was intended to unroll on the other side of the lectern or pulpit, giving the congregation the benefit of the illustrations.)

British Library, Department of Manuscripts, Add. MS 30337, sixth subject.

FIGURE 31 Walrus ivory chess pieces, from the Lewis Chessmen.
pages 92–3

A king, wearing a floriated crown, sits holding his sword in its scabbard across his knees; his chair is carved with interlace and, on the back, with vegetal and animal ornament.

A queen, wearing a floriated crown, holds a horn in her left hand; her right hand rests against her cheek. Her chair is decorated with interlace and, on the back, with vegetal and animal ornament.

A mounted knight wears a conical helmet and carries a triangular shield and a lance.

A bishop, mitred, stands with a book in his right hand and his pastoral staff in his left.

Heights 10, 9·5, 8 and 9·5 cm respectively. Twelfth century. English or Scandinavian; from some seventy-eight walrus ivory chess pieces found on the Isle of Lewis, in the Outer Hebrides.

British Museum, Department of Medieval and Later Antiquities. *Catalogue of ivory carvings*, nos 79, 84, 109, 98.

FIGURE 32 Limestone capital.

page 95 The Miraculous Draught of Fishes (Luke 5:4 ff).

Two disciples in a boat draw up a bulging net; one also holds an oar.

Height 25·5 cm. Twelfth century. From Lewes Priory, Sussex.
British Museum, Department of Medieval and Later Antiquities, no. 39,10–29,43.

FIGURE 33 Page from the Worms Bible.

page 96 The opening of the Book of Genesis.

The large ornamental panel contains the first two words of Genesis, IN P[R]INCIPIO. The whole length of the panel is occupied by the letter 'I', which consists of a long shaft filled with interlace, with figure medallions above and below. The upper medallion shows the Creation of Light, with Christ as the Creator giving the command to three angels, the lower the Creation of Eve, with Adam lying asleep and Eve rising from his side at the command of Christ. Half-way down the shaft of the 'I' a large 'N' is interlaced with it, while the remaining letters are distributed on either side, above and below. Intervals between the letters and the frame of the panel are filled with floral scrolls issuing from the letters 'I' and 'N'.

Panel 39 × 11·5 cm. 1148(?). Rhenish; in the seventeenth century the manuscript was in the church of St Mary, Worms.
British Library, Department of Manuscripts, Harley MS 2803, folio 6b.

FIGURE 34 Bronze-gilt censer-cover.

page 99

The cover has the shape of a building with a central tower and four arms surmounted by turrets. At the ends of the four arms are half-figures of angels enclosed in foliate scrolls, between which are the half-figures of lions. In the angles between the arms of the building are the symbols of the four evangelists.

Height 13 cm. Late twelfth century. Lower Rhine or Meuse region.
British Museum, Department of Medieval and Later Antiquities, no. 1919,11–11,1.

FIGURE 35 Miniature from the Westminster Psalter.

page 101 Christ in Majesty.

Christ is seated on a rainbow in a mandorla, holding an open book on his left knee, his right hand raised in benediction. Round him are the symbols of the four evangelists.

Panel 16 × 10·5 cm. About 1200. Made for Westminster Abbey.
British Library, Department of Manuscripts, Royal MS 2A.XXII, folio 14.

FIGURE 36 Miniature from the Floreffe Bible.

page 102 The Crucifixion and the sacrifice of a calf.

The headpiece to the Gospel of St Luke has figural scenes in two compartments. In the upper is the Crucifixion with two soldiers: on the left, Longinus pierces Christ's side with his spear and, on the right, Stephaton holds

up the sponge filled with vinegar. In the lower compartment, corresponding to the figure of Christ, a priest, possibly Aaron, kills a calf on an altar. Christ's sacrifice is thus related to the slaying of the calf, the sin-offering of the Old Testament (Leviticus 9:2). This is explained by the inscription on the arch:

Pro nevo fraudis vitulus datur hostia laudis
Quod Christus vitulus sit docet hic titulus

('In recompense for the blemish of the fraud [the original sin], a calf is given for a praise-offering. That Christ is that calf this title-picture shows'). The meaning is emphasised by the addition of Old and New Testament figures holding scrolls with quotations from their writings, all referring to sacrifices. Above are St Paul, with a text from his epistles (Hebrews 9:12), and David, with a quotation from the Psalms (Psalm 110:4). Below are David again, with another text (Psalm 69:31), and St Luke, carrying his symbol, a winged calf, and a scroll with a quotation from his Gospel (Luke 15:22f.).

Panel 27·5 × 13·5 cm. About 1160. Made in the Abbey of Floreffe, on the Meuse.
British Library, Department of Manuscripts, Add. MS 17738, folio 187.

FIGURE 37 Page from a bestiary.
page 105

At the top are an ibex falling from a cliff, and three huntsmen, one carrying an axe, another blowing a horn, the third holding a bow. Below, a hyena devours the corpse of a woman it has dragged from a stone coffin. The moral interpretation given to their subjects by the writers of bestiaries may be illustrated by a translation of the text on this page:

> There is an animal called the ibex, which has two horns of such strength that, if he were cast down from a top of a mountain to the depths, his whole body would be supported by them. He signifies, indeed, the learned men, who are wont to hold at bay their ill-fortune through the agreement of the two Testaments, as if by a certain inherent strength of their nature, and, as if sustained by the two horns, they support their good deeds by the testimony of the Old Testament and the Gospel lesson.

Width of panels 15·5 cm. Late twelfth century. English.
British Library, Department of Manuscripts, Harley MS 4751, folio 10.

FIGURE 38 Fragment of ivory inhabited scroll.
page 107

The openwork design incorporates the figure of a man in a short tunic standing in a vegetal scroll and grasping a stem with both hands; at the bottom is a beaded border.

Height 6 cm. Twelfth century. English. Found at St Albans on the site of what is believed to have been the abbey infirmary.
British Museum, Department of Medieval and Later Antiquities, no. 1921,6–8,1.

FIGURE 39 Page from a manuscript of Simeon Metaphrastes' lives of
page 109 saints. The martyrdom of St Anthimus.

The headpiece of the Life of St Anthimus has a portrait of the
saint and four scenes from his martyrdom. Above, to the left, the emperor
Maximian, seated on a throne, sends out messengers to take St Anthimus
prisoner; to the right, the messengers on horseback find the saint in his retreat.
Below, to the left, the saint is tortured on a wheel in the presence of the Emperor;
to the right are depicted the saint's last prayer and his execution.

Panel 18 × 10 cm. Eleventh or twelfth century. Byzantine.
British Library, Department of Manuscripts, Add. MS 11870, folio 44b.

PLATE I Gold-glass fragments, gold foil between two layers of glass.
see page 14

The bottom of a drinking-vessel with busts of a bride and bride-
groom and Cupid laying his hands on their heads. The inscription reads: . . . NE
TZVCINVS BIBITE ('May . . . [and] . . . Tzucinus drink').

Diameter 7 cm. Fourth century. From the Roman catacombs.
British Museum, Department of Medieval and Later Antiquities, no. 63,7–27,11.
Catalogue of Early Christian antiquities, no. 612

The bottom of a drinking-vessel with busts of a bride and a bride-
groom and Christ holding a wreath over each head. The retrograde inscription
reads: DVLCIS ANIMA VIVAS ('May you live, sweet soul').

Diameter 5·5 cm. Fourth century. From the Roman catacombs.
British Museum, Department of Medieval and Later Antiquities, no. 98,7–19,1. *Cata-
logue of Early Christian antiquities*, no. 613.

PLATE 2 Mummy-case.
see page 17

The mummy-case is that of Artemidorus, whose portrait is painted
on a wooden panel.

Height 167 cm. Second century. From Hawara, in the Fayyum (Egypt).
(The mythological scenes imitate those on coffins of the dynastic period. An inscription
in Greek reads 'O Artemidorus, farewell!' The mummy is that of a young man of about
twenty years of age.)
British Museum, Department of Egyptian Antiquities, no. 21810. *Handbook to the
Egyptian mummies and coffins*, p. 13, pl. VI; *Catalogue of Egyptian antiquities in the British
Museum*, 1, Mummies and human remains, p. 35, pl. XVIId.

PLATE 3 Fragment of a leaf from the Cotton Genesis, an illustrated
see page 31 Bible in Greek.

The miniature illustrates Genesis 19:11: Lot (left) defends his house against the Sodomites.

Fragment 11 × 9·5 cm. Fifth or early sixth century. Probably from Egypt.
British Library, Department of Manuscripts, Cotton MS Otho B.VI, fragment 4.

PLATE 4 Woven silk panel. A hunting scene.
see page 42

Two figures of horsemen, with dogs and lions, are contained in a medallion. The rectangle, of compound twill, decorates the remains of a linen-lined silk garment.

Height of panel 24 cm. Seventh century. Coptic.
British Museum, Department of Egyptian Antiquities, no. 17173.

PLATE 5 'Carpet-page' from the Lindisfarne Gospels.
see page 49

The page prefacing St Mark's Gospel has been treated ornamentally.

Panel 24 × 18 cm. Late seventh century. Northumbrian.
According to a tenth-century note, these Gospels were written by Eadfrith, who was Bishop of Lindisfarne from 698 until 721.
British Library, Department of Manuscripts, Cotton MS Nero D.IV, folio 94b.

PLATE 6 Miniature from the Harley Golden Gospels.
see page 56 Portrait of St Matthew

The evangelist is sitting on a chair writing his Gospel; behind him, in an elaborately framed niche, is his symbol, the angel.

Page 36 × 24 cm. Early ninth century. Carolingian, 'Ada Group', probably made at Aachen.
British Library, Department of Manuscripts, Harley MS 2788, folio 13b.

PLATE 7 Miniature from the Moutier-Grandval Bible.
see page 58 Moses receiving the Law and teaching it to the Israelites.

Above, Moses on Mount Sinai, surrounded by flames, receives the Law from the hand of God, stretched out from heaven; on the left is Joshua (Exodus 24:13ff.). Below, Moses in a hall teaches the Law to the Israelites led by Aaron (Exodus 34:31f.); to the left, Joshua holds up a curtain.

Panel 40·5 × 29 cm. Between 834 and 843. Carolingian, made at Tours. In the late sixteenth century the manuscript belonged to the monastery of Moutier-Grandval, near Basle (Switzerland).
British Library, Department of Manuscripts, Add. MS 10546, folio 25b.

PLATE 8 Page from the Harley Golden Gospels.
see page 62

The opening words of St Luke's Gospel have been given an ornamental setting; enclosed in the letter 'Q' are busts of the Virgin and St Elisabeth and the scene of Gabriel appearing to Zacharias (Luke 1:11ff).

Panel 32·5 × 21·5 cm. Early ninth century. Carolingian, 'Ada Group', probably made at Aachen.
British Library, Department of Manuscripts, Harley MS 2788, folio 109.

PLATE 9 Miniature from a Gospel-book in Greek. Portrait of St Luke.
see page 72

The Evangelist is seated at a desk composing his Gospel; behind him is an arch from which a lamp is suspended. Writing implements and materials lie on the desk and the floor.

Panel 17 × 12·5 cm. Tenth century. Byzantine.
British Library, Department of Manuscripts, Add. MS 28815, folio 76b.

PLATE 10 Miniature from the Grimbald Gospels. Portrait of St Luke.
see page 75

The evangelist is seated on a chair with a writing-desk by his side, while his symbol, the winged bull, dictates the Gospel.

Outer frame 21 × 16·5 cm. Early eleventh century. Anglo-Saxon, Winchester School.
British Library, Department of Manuscripts, Add. MS 34890, folio 73b.

PLATE 11 Miniature from an Ottonian Gospel-book.
see page 83 The Annunciation.

The figures of Gabriel and the Virgin are enclosed in a city represented conventionally.

Panel 18 × 13·5 cm. Early eleventh century. Ottonian, from the Monastery of Echternach, near Trier.
British Library, Department of Manuscripts, Harley MS 2821, folio 22 *recto*.

PLATE 12 Miniature from the Silos Apocalypse, a manuscript of
see page 87 Beatus's Commentary on the Apocalypse (the Book
of Revelation).

The miniature shows the Four Horsemen of the Apocalypse (Revelation 6:2ff.).

Panel 32 × 20·5 cm. Between 1091 and 1109. Made for the Abbey of San Domingo, Silos.
British Library, Department of Manuscripts, Add. MS 11695, folio 102b.

PLATE 13 Copper-gilt and enamel cross with semi-precious stones.
see page 97

The cross has champlevé enamel figural scenes at the end of each

arm and in the centre, separated by champlevé enamel ornament. At the top, supported by a column, is the Brazen Serpent, a symbol of the crucified Christ, flanked by Moses and Aaron (Numbers 21:8). On the left, Elijah visits the Widow of Zarephath, who has been collecting sticks (1 Kings 17:8ff.), a symbol of the Cross. At the bottom, Joshua and Caleb carry grapes from the brook of Eshkol, in the Promised Land, on a staff between them (Numbers 13:23), a symbol of Christ on the Cross. On the right, an Israelite in Egypt, with the blood of the lamb, striking it 'on the two side posts and on the upper door post of the houses' (Exodus 12:7) in the shape of the Greek letter *tau*, T, a symbol of the cross. In the centre, Jacob blesses Ephraim and Manasseh; his arms are crossed so that his right hand rests on the head of Ephraim (Genesis 48:13–14), thus preferring the younger, a symbol of the New Covenant, as represented by the Crucifixion, replacing the Old.

Height 37·5 cm. Thought to have been made by Godefroid de Claire, a native of Huy, who worked in the Meuse region in the third quarter of the twelfth century.

(The other side of this cross, in the Kunstgewerbemuseum, in Köpenick, Berlin, has scenes depicting the discovery of the True Cross by St Helena, mother of Constantine the Great.)

British Museum, Department of Medieval and Later Antiquities, no. 56,7–18,1.

PLATE 14 German miniature. The Visitation.
see page 100

The Virgin and St Elisabeth (Luke 1:40) are shown in a gold ground with incised scroll ornament.

Panel 21·5 × 13·5 cm. Twelfth century. Probably from a psalter.
British Library, Department of Manuscripts, Cotton MS Caligula A.VII, folio 4b.

PLATE 15 Miniature from the Winchester Psalter.
see page 106 Scenes from the Passion.

Above, the Betrayal. Judas embraces Christ, whose hand is grasped by a soldier carrying a club; on either side, men with grotesque faces carry various weapons; in the background, St Peter cuts off the ear of Malchus (John 18:10). Below, the flagellation. To the left, Pilate, wearing a crown, is seated on a throne (Matthew 27:19; John 19:13); the Devil, in the shape of a black beast, whispers in his ear.

Panel 27·5 × 17·5 cm. Mid-twelfth century. Also known as the Psalter of Henry of Blois; made for St Swithin's Priory, Winchester.
British Library, Department of Manuscripts, Cotton MS Nero C.IV, folio 21.

PLATE 16 Miniature from a manuscript of Bede's Life of St Cuthbert.
see page 110

St Cuthbert and his companions sail back from the island of the Picts.

Panel 10·5 × 7 cm. Late twelfth century. Probably made at Durham.
British Library, Department of Manuscripts, Yates Thompson MS 26, folio 26.

127